Watercolour
Impressionists

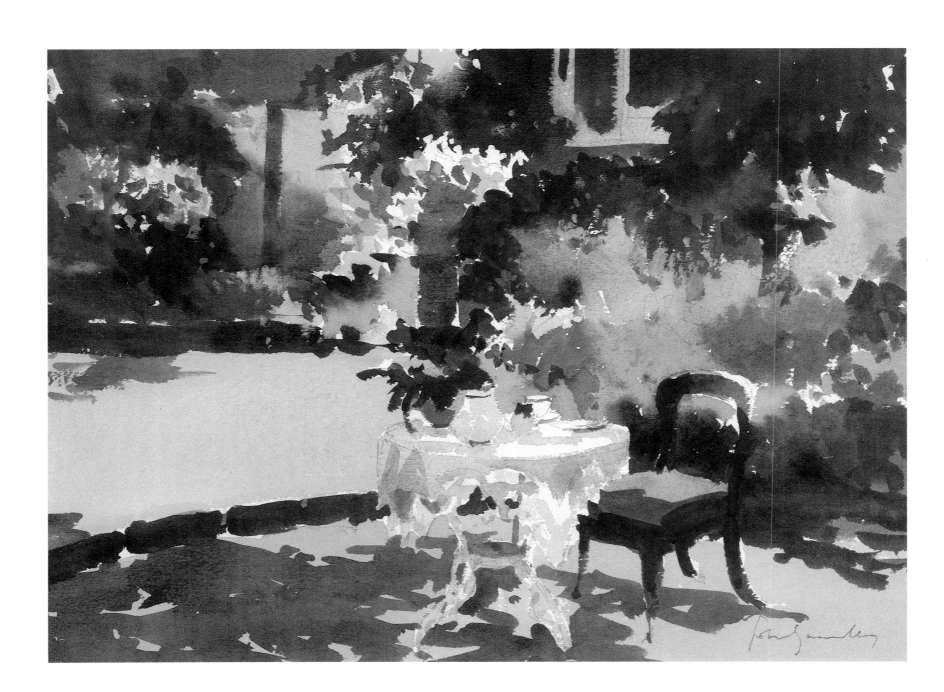

Watercolour Impressionists

RON RANSON

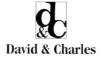

David & Charles

Acknowledgements

Frontispiece
◁ TEA IN THE GARDEN, *John Yardley*
There's a lovely impression here of brilliant
sunshine and dappled shadows. The eye is
drawn first to the purple flowers on the wrought-
iron table. The white table itself, indicated with
utmost economy, gives a feeling of purpose to the
painting. A contrasting note of solidity is
provided by the dark chair so obviously brought
out from the dining room.

A DAVID & CHARLES BOOK

First published in the UK in 1989
Reprinted 1990, 1991, 1993
First paperback edition 1997

A catalogue record for this book is available from the
British Library.

ISBN (hardback) 0 7153 9338 3
ISBN (paperback) 0 7153 0694 4

Typeset by Character Graphics, Taunton
and printed in Singapore by CS Graphics Pte Ltd
for David & Charles
Brunel House Newton Abbot Devon

Producing this book has been like a worldwide treasure hunt and without the help and co-operation of many people, it would never have happened.

First, the artists themselves: Trevor Chamberlain; Frank Webb; Douglas Treasure; John Yardley; Claude Croney; Tony Couch; Don Stone, Barbara Crowe, Philip Jamison, Tony Van Hasselt and Judi Wagner, in the order they appear. Four artists are sadly no longer with us, and I would like to thank their dependants and Estates for their help; Mrs Seymour for the use of Edward Seago's work, Mrs Merriott and Ernest Savage for their help on Jack Merriott, Mrs Wesson who kindly lent many of her husband's transparencies and Mrs Russell Flint who gave permission to use Sir William's paintings.

Five galleries were most helpful and deserve thanks: Alexander Gallery in Bristol lent material on John Yardley and Edward Wesson; Thomas Gibson Fine Art Ltd, Richard Green, and Spink & Son Ltd lent transparencies of Edward Seago, and finally, Keith Gardner of the Sir William Russell Flint Galleries.

I design and lay out my books at home in St Briavels, persuading friends and neighbours to help. Ann Mills has helped enormously with the writing; Janet Broughton did all the typing, Karen Mitchell assisted with layout and her father, Ray, did much of the photography.

CONTENTS

Introduction

Writing this book was a labour of love for me. As one who came to watercolour relatively late in life and having to start from scratch, I needed heroes to inspire me and spur me on, just in the way that budding golfers need a colourful character like Steve Ballesteros to fuel enthusiasm and provide a guiding light. The artists you choose, of course, must be producing the type of work to which you yourself aspire. Of the many whose work attracted me, Edward Seago was without doubt the strongest influence. His economy of brush stroke, made possible by his keenness of observation, was a powerful magnet.

My recent book about him was a personal tribute and, fortunately, enormously successful. This in turn opened more doors and has offered me the chance to pay tribute to some other contemporary artists who, unknowingly, have helped form my own approach to watercolour.

I have spent many hours scouring bookshops in my travels round the world during the last few years. I could find hundreds of books about the French Impressionists, the Old Masters, the Victorians and many modern artists whose work was so far advanced in concept as to be mystifying. The metaphoric gap in the shelves was the area in which I, and thousands like me, needed more information – there were simply not enough books on contemporary watercolours. One could, of course, always find books of basic instruction, but material on the work of inspiring, modern, naturalistic painters was almost non-existent.

I was searching for painting in which the subject matter was recognisable but streets away from the photographic approach; work that had been done with freedom and courage, allowing viewers to exercise their imagination, something which they would find exciting and stimulating.

Now, my publishers have given me this golden opportunity to fill this gap by producing my own collection of heroes and heroines. I must emphasise here that these represent my personal taste, but I do hope that many of you will agree.

I began by listing my favourite watercolour artists worldwide, restricting the list to about fourteen to enable me to do justice to each one. Some were personally known to me but others I had never met and it is to their credit, or in some cases their families', that they were willing to trust me to provide an adequate showcase for their work.

Having received everyone's permission and approval, the next task was to blend as sympathetically as possible the various personalities and their work. You'll find no logical order to the list, alphabetical or otherwise. The aim has been to provide a series of contrasting approaches – peaceful against dramatic, colourful against subtle – to stimulate and excite you. In painting terms, I've used as much 'counterchange' as possible.

As with the Seago book a very important part of the writing lies in the captions. These needed to be more than just titles and polite comment. I have attempted in each caption,

◁ OCTOBER MORNING ON THE BAÏSE,
Sir William Russell Flint
There's a terrific mixture of subtle greens within this picture – the cool grey-greens in the distant trees contrasting with the warm, dark, rich greens in the foreground. There is absolutely no detail in the foliage, nor is it necessary. Throughout he's used plenty of counterchange in the trunks – light against dark, dark against light.

to present not only my own feelings about the work but also what can be learnt from each example. You probably won't agree with every statement but at least I hope that it will stimulate you to look more deeply into each painting which, in turn, will increase your awareness and painting skills.

To make clear the reason for my choice of title, it might be helpful at this point to look briefly at the history, aims and ideals of the Impressionist tradition.

First, let's try and define Impressionism. For the original Impressionists, a picture needed to be painted in as much direct contact as possible with the subject, to be seen and not imagined, remembered or invented. It had to be painted as a whole, without re-composition in the studio. As for the subject matter, Impressionist paintings were conceived in the world that the artists actually lived in, from the scenes, people and landscapes they knew. Most of the paintings were started and finished out in the open.

If you apply this description of Impressionism, then surely the first of them all was J.M.W. Turner – a genius, a century ahead of his time. He demonstrated a new approach to the problems of atmosphere by painting the effects of light and mist. Like those of the Impressionists who followed him, many of his works were unintelligible to his contemporaries and it needed the later development of non-figurative art to make them acceptable to modern taste. Turner's work, however, is inexhaustible as a source of fresh experience.

Another genius was Constable, who was the first landscape painter to consider painting or sketching direct from nature at a single sitting as essential. His idea of a spontaneous impression contained the germ of what we consider ideal in modern landscape. He discovered the abundance of life in the simplest country scene – rustling trees, gentle streams and tall reeds, all expressed with a creative and vivid palette. He audaciously introduced the greens of lush meadows and summer foliage which, until then, other painters had been unable to capture, and recognised light as the all-pervading element in the landscape. His work has had an enormous influence on those who came after him.

How, then, did the term 'Impressionism' come about? In 1874 a group of young *avant garde* artists, whose work had been effectively banned by the official Paris salon, decided to defy the authorities and hold their own 'fringe' exhibition on the premises of the photographer Nadar. Few people came to see the show, and even fewer bought pictures, so financially it was disastrous. The reviewers, too, on the whole were unfriendly towards it, and either passed the exhibition over in silence or mocked the efforts of the artists involved. One critic, Leroy, wrote an article about the event, in which he made disparaging remarks about various paintings, including one by Claude Monet called *Impression, Sunrise*. It was a view of Le Havre harbour seen through early morning mist. Borrowing from the name of this picture, he called the group 'Impressionists' in

the title to his article. It was intended as an insult, but the name stuck and spread throughout the world to describe the first revolutionary movement of modern painting.

This exhibition was the beginning of eight years when this group of painters worked and showed together, and kept in constant touch with each other – the flowering of the movement. Monet, Renoir, Sisley, Pissaro and Manet were its orginators and its most important members. All their work has been covered in depth many times – it's difficult to wander round any art book shop without being almost overwhelmed by rich, grandiose volumes showing their paintings and describing their lives. However, Monet was undoubtedly the dominant force in the development of Impressionism. He had a deep and profound love of nature and was dedicated in his search to find the most perfect way of depicting it in a painting. It was this obsession that set and kept him and his friends on the path to Impressionism.

Fundamental to the development of this movement was the belief that the sensation received in the open air was far more important than the actual motif. They felt that to work up a landscape in the studio inevitably dulled and falsified the impression obtained on the spot. Monet and his comrades became convinced that the sombre colours and brown shadows used by the traditional landscapists of the day were untrue to nature. They also became aware that shadows were in fact coloured by the objects around them. They wanted to let nature speak through

them rather than impose their preconceived ideas on it. Their paintings constituted an entirely new type of exhibition picture. Instead of the large classical works fashionable at the time, they were small, informal in composition, and freshly and spontaneously painted, showing everyday scenes treated in bright clear colour. Yet at the time this vision seemed completely unintelligible to critics and public alike – almost the antithesis of art.

Slowly but surely, however, the Impressionists' way of painting caught on; by the turn of the century it had swept throughout the western world and some of the originators of the movement had become rich and famous. But it was too late for others like Manet and Sisley, whose works only soared in value after their death. The group still exhibited until 1886, but gradually its members drifted apart.

To see the movement from oils to watercolour in impressionistic painting we have to look to America, where two men exerted an enormous influence. They were Winslow Homer (1836-1910) and John Singer Sargent (1856-1925). Winslow Homer was the most popular of all American watercolourists. He was completely self-taught and worked for much of his life as a conventional traditional artist, mainly in oils; but for the last twenty-five years of his life he concentrated on painting glorious watercolours. While his contemporaries regarded watercolour merely as a sketching method and not a serious means of expression, he stretched its possibilities to the limits and gave it prestige as a medium in

its own right. His first watercolour exhibition in Boston was a sensation, and his vibrant colour, free brush work and bold spontaneous washes have dominated American watercolour painting since. This pinnacle of achievement was shared only by Sargent.

It is a coincidence that in 1874, the same year as the first Impressionist exhibition, the eighteen year old John Singer Sargent was taken by his parents to Paris where he came to study portrait painting under Carolous. He showed enormous talent and eventually became famous as a portrait painter of Edwardian and Georgian high society. Much sought after in both England and America, a portrait by Sargent became the ultimate prestige symbol. Honours were showered on him and he was elected to the National Academy in New York, the Royal Academy in London and as an officer of the Legion d'Honour of France. However, he gradually became disillusioned and discontented with his continual portraits. After about 1905 his output of these declined and he began to paint more and more in watercolour. This seemed to release Sargent from his contraints and he was soon painting with tremendous dash and bravado. His first exhibition of 86 watercolours in New York in 1909 was a triumph. The Brooklyn Museum bought nearly all of them, thereby starting a phenomenon, with other museums clamouring for them. The Metropolitan Museum bought 11; the Boston Museum bought 45. In 1917 the Carnegie Institute mounted an important exhibition in which the works of

Sargent and Winslow Homer were shown.

Sargent watercolours obey the real requirement of art in the most important way – they endure and are timeless, remaining as fresh as the day they were painted. I look regularly at reproductions of his work for inspiration and guidance. They might have been painted in the 1980s, although most of my own favourites date from about 1907.

The artists collected here are, I feel, the worthy successors of the original group, following in their traditions and holding to their ideals. I have tried to convey some of the personality of each artist rather than just boring facts, figures and dates.

This book has also provided me with a wonderful 'spin-off' – the opportunity to meet and get to know personally many of the artists themselves, leading, I hope, to a series of long and lasting friendships. These meetings have taken place as far apart as in English cottages and on American islands. The unifying factor has been the warmth of their welcome. Why are artists such nice people? It must be something to do with job satisfaction and contentment.

It is to be hoped that *Watercolour Impressionists* will be read by the many amateur artists who are searching for an individual approach to watercolour painting – one with which they can identify personally. There are, of course, as many approaches and techniques as there are artists, but I feel that the fourteen described provide between them an enormously wide and stimulating range of possibilities.

Trevor Chamberlain ROI RSMA

'I don't really like selling my paintings – I put so much of myself into them,' he said hesitatingly. Those few words possibly hold the key to Trevor Chamberlain's character and paintings. I had bought eleven paintings from him over a couple of years and it seemed that each one had to be prised from him, gently and patiently. He admitted that, although he knows he has to sell them eventually, he tries to keep them with him for as long as he can before parting with them. It may also account for the quality of complete sincerity and integrity that emanates from each work. Here there is none of the dashing bravado and showy technique that can sometimes impose itself on the subject matter, which can make the scene itself seem almost of secondary importance. He is content to let the subject speak for itself, using his skills to portray it with as little intrusion as possible.

While working on a previous book I joined Trevor on a search for a subject. He was unmoved by all the dramatic views I suggested. His final choice was a site that I had driven past many times without a second thought; what he had seen was the play of light on a certain building. This became the focal point of a very fine painting. The effect of light is everything to him and it is the constant theme which runs through his work, whether it be oils or watercolour.

This quality of sincerity may also be partly due to the fact that, unlike many artists, he paints almost always on site in the open air, feeling that it gives him a far more intimate relationship with his subject. His constant search for lighting effect has led him into unlikely and, what most of us would consider mundane, subjects. I once asked him why he chose to paint a London bus garage and he said that it was the play of light on the diesel fumes that excited him!

This method, of course, makes him something of a slave to the weather and limits his paintings to about two a week, but he's by no means a 'fair weather' painter as I know to my cost. I have held umbrellas over him and stood and shivered in windy fields while watching him work. Many of his paintings, both oil and watercolour – which he produces in equal quantities – are done from the front seat of his car. His equipment includes

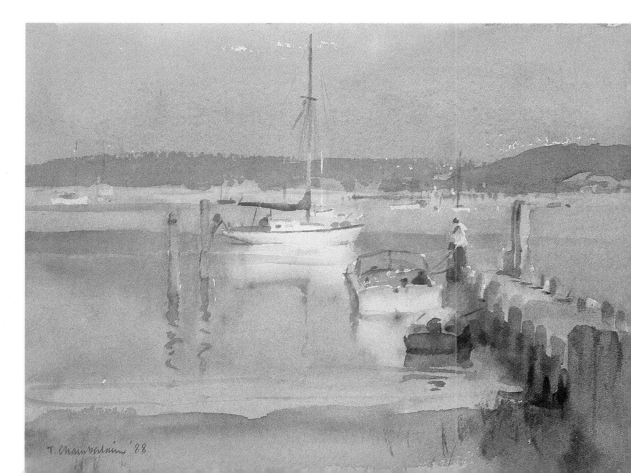

THE FLOWER SELLER, BOW CHURCH ▷
This is an excellent vertical composition. The lovely dapple light on the walls is a reflection from the office windows opposite. The lady flower seller sternly refused to let him paint her so he had to surreptitiously photograph her and went back on a Sunday morning to paint the rest of the scene. Most of the painting is in subdued colour emphasising the brightness of the flowers.

◁ EVENING AT EDGARTOWN
He did this painting on a recent trip to the US. He attempted in this late evening subject to show the strong contrast between the warm light on the boats and the cool tones of the water. Notice how the line of the pier and the distant yacht both direct the eye to the single figure.

◁ WINTER MORNING
Here he has captured the subtle atmosphere of early morning sunshine gently penetrating the mist. He has made full use of puddles to reflect the bright colour of the house, and contrasted this with the shadowy foreground. The figure disappearing into the distance lends a slight air of mystery.

GREY MORNING, ROTHERHITHE ▷
This fascinating subject has a diagonal composition. The all-over grey atmosphere is shown in the crumbling walls and rusty barges, but throughout there's a wonderful amount of subtle colour – I couldn't resist buying this.

a tiny hairdryer which plugs into the car's cigar lighter.

He is completely self-taught, having started to paint as a teenager. He worked as an architectural draughtsman, but in 1964 became a full-time professional artist. For many years watercolour took a back seat to oils. However, in 1970 he determined to concentrate on mastering watercolour and by the end of the year had become equally proficient in both media. He and his work are respected throughout his profession and his list of achievements and awards is long and impressive.

When painting, he sketches in the bones of his subject, then quickly sponges the paper lightly to make the paint flow more easily. His choice of paper is wide and he experiments with various makes and surfaces – he even has stocks of the legendary pre-war Whatman paper – but he avoids hot pressed paper because it doesn't suit his style. He prefers to stand while painting, whenever possible, as it gives him more freedom. He works fairly flat at a 15 degree angle, using mainly a No 12 sable, and also uses an old shaving brush for larger areas. A No 8 sable and a rigger complete the list.

His limited palette is raw sienna, Venetian red, alizarin crimson, olive green, veridian, cobalt, ultramarine blue and burnt umber, but he also keeps burnt sienna, cadmium yellow and cadmium red up his sleeve for occasional use.

Many of his subjects are in the countryside surrounding his home near Hertford, but he makes occasional forays to London (he is a member of the famous Wapping Group on the Thames) while Liverpool, too, provides him with inspiration. A favourite picture by him is one of a Liverpool street in the rain. Some of the watercolours shown here were done on a recent trip to America with the RWS.

As an artist, he causes me great expense – I hardly ever meet him and look at his paintings without wanting to buy at least one. Most recently it was *Grey Morning, Rotherhithe*, on page 13 and I also own the one on page 18, *Al Fresco*. Could I pay him a more sincere tribute?

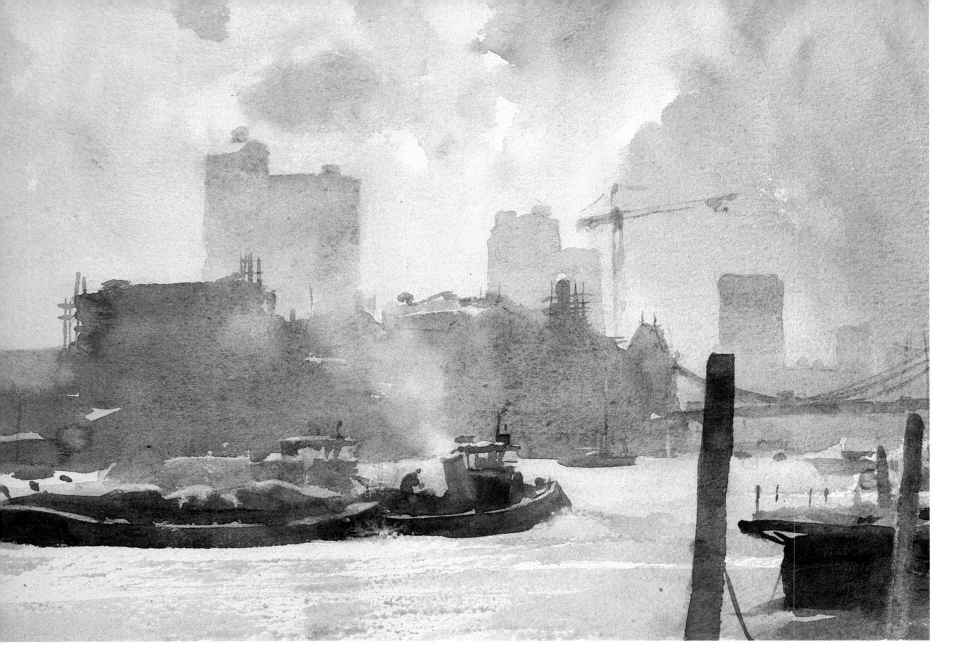

△ OFF WAPPING
This is an atmospheric painting in the grand manner. Here Trevor has captured all the activity of the Thames that comes with the high tide. Notice the three separate tonal areas which give depth to the painting and the subtle, yellow light in the sky that blends with the greys.

NORTHAMPTONSHIRE VILLAGE STREET ▷
A very simple composition here. There was, he said, very little light to create any real contrast. He felt that the inclusion of the rubbish skip avoided any suggestion of prettiness and sentimentality. The three figures, too, are an important part of the composition.

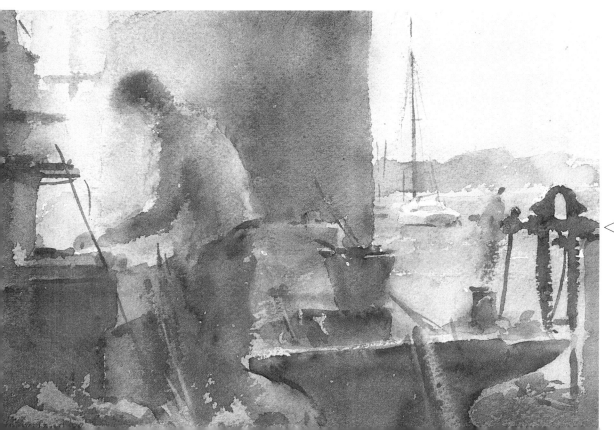

◁ MARINE BLACKSMITH
Painted in America, this subject presented a real challenge. Trevor wanted here to convey the two different sorts of light – the clear sunlit exterior contrasting with the smoke and heat of the blacksmith's furnace. This picture typifies Trevor's pre-occupation with light.

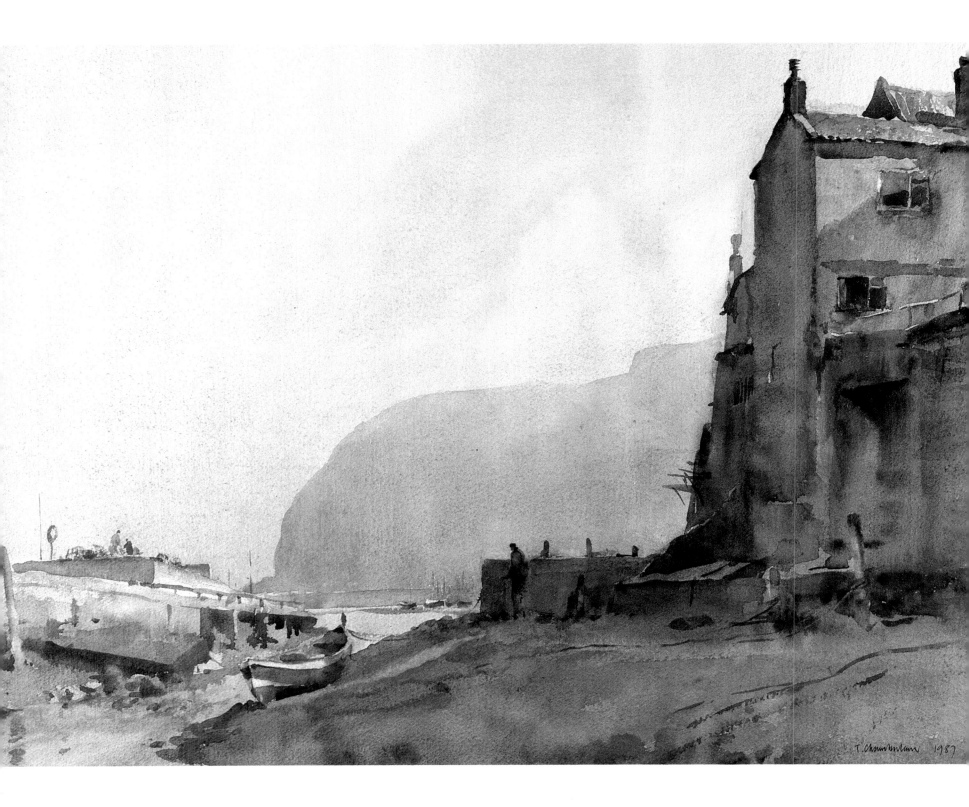

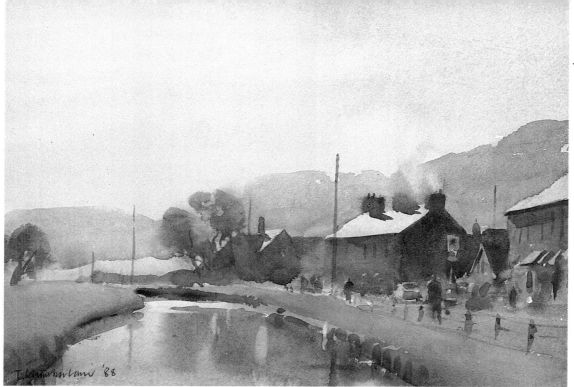

◁ BY THE NEW RIVER AT WARE
This is a morning subject with plenty of light and colour. The focal point of the picture is the light roof contrasting with the adjacent dark gable end. Notice the way the light at the end of the river contrasts with the dark tone of the bank behind it.

ON THE HARD, SOUTHWOLD ▷
The sharp contrast of the white superstructure against the black hull makes the boat the main object of interest in the picture, and its position in the composition is very important. The complex detail has been greatly simplified throughout, and there is some very subtle colour in the texture of the foreground shed.

◁ SEPTEMBER MORNING, STAITHES
A very strong 'L'-shaped composition in which the dramatic foreground in deep shadow contrasts sharply with the light atmosphere beyond. Notice the wealth of subtle colour in the shadows, and the way the sunlight just catches the top of the house.

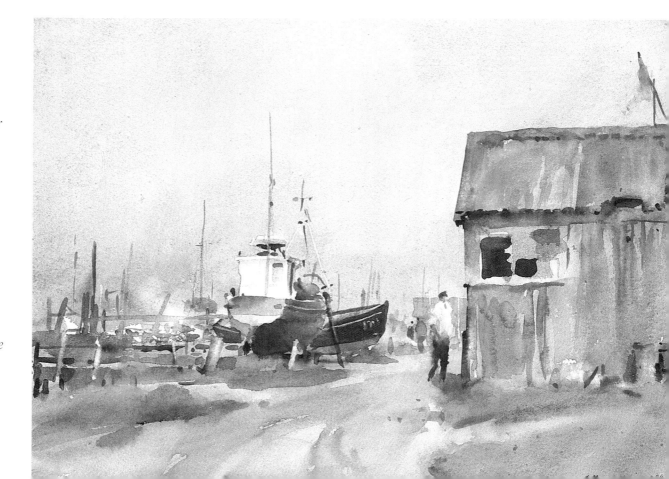

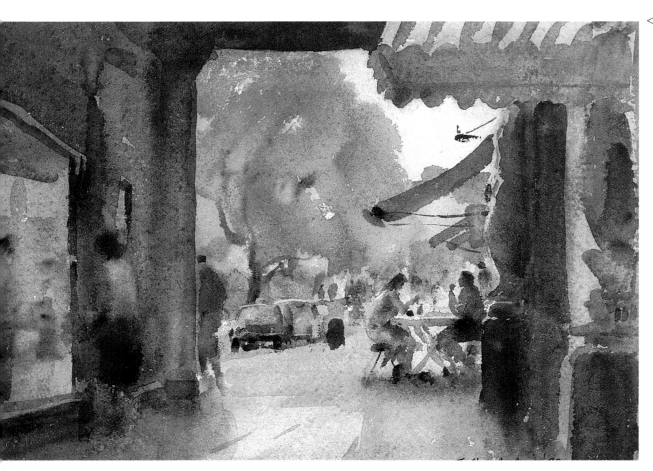

AL FRESCO, CHELTENHAM
I know this scene well and bought it as soon as I saw it. Most of the detail and counterchange is concentrated around the couple at the table, making them the centre of interest. I like the way the figure in the left foreground is portrayed out of focus wet-into-wet so as not to compete with them.

HAZY SUN AND DAMP MIST ▷
This large full sheet picture was painted outside in very difficult conditions – blowing hard with occasional rain. Trevor stood in a ditch under a hedge for protection. Despite this he has completely captured the wonderful atmosphere and sense of space. Again he has used the device of a light roof against a dark gable to attract the eye. The painting is a triumph of determination over adverse weather conditions.

HAZY LIGHT, HAMMERSMITH ▷
Whilst Hammersmith Bridge is merely suggested, the strong counterchange of the foreground boats makes this a very strong picture. The reflections in the calm water are also handled with great skill and economy, with much of the surface left untouched. It would have been so easy to overwork this area.

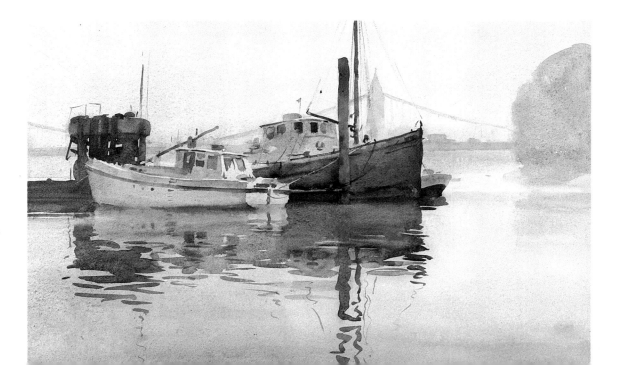

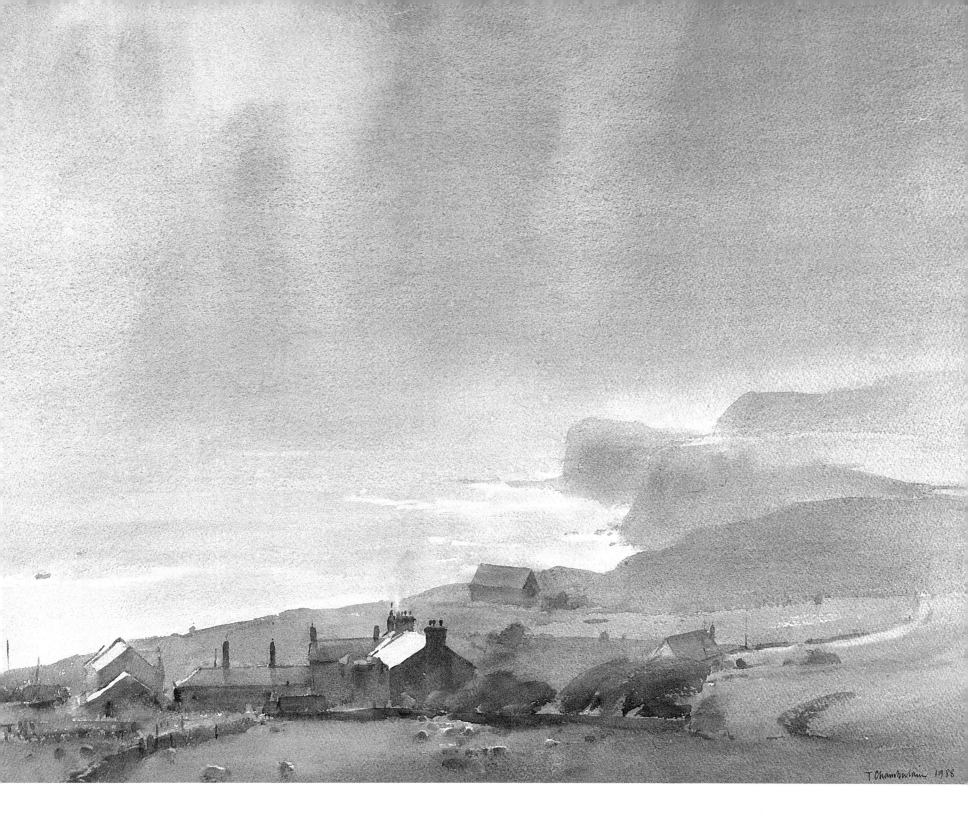

Frank Webb *AWS*

Frank Webb is a watercolourist with a difference. He has a rare combination of scholarly interest in aesthetics and a contagious enthusiasm for the medium.

His work thrills and excites me, and he's so far advanced in his approach and application that I shall never be able to catch him up. It's rather like the fashion houses of Paris whose influence, somewhat diluted, can be seen in High Street fashions; so Frank Webb's influence can be detected in the work of many of his contemporaries, particularly in America.

As an artist, he's universally respected and admired, honoured with awards from the American Watercolour Society, such as the Bronze Medal of Honour, the Mary Pleissner Award, and the Sisek Award from the Butler Institute of American Arts. His work has been exhibited worldwide and his water-

colours are in numerous public and private collections.

Frank Webb, a native of Pittsburgh, studied at the Art Institute of Pittsburgh. From 1957 to 1980 he was president of an art and design firm that served many major industrial clients. He is now a guest instructor, lecturer and juror for art associations and museums throughout the United States, Canada and Mexico.

His book *Watercolour Energies* is an exciting challenge to any artist, exploring many new areas of painting and design. As well as the usual chapters on materials and methods he delves into the more rarefied realms of conviction, space, pattern and aesthetics.

Frank Webb is a man of deep convictions, not only about his life but also about his art. This becomes very evident upon reading his book. Perhaps one can be excused for including a partial list of these convictions about painting as I feel they help to reveal the nature of the man:

> Motivation precedes action
> Art is deliberately designed
> Art interprets experience
> The quest for beauty requires
> craftsmanship
> Failure is a stimulus.

You probably realise by now that his book has had a tremendous effect on me as, of course, have his paintings.

His attitude shows in his paintings which are abstracted and designed to a far greater degree than is generally seen. His sense of overall pattern and structure is enormously

powerful. This may possibly have been influenced by his many years in industrial design.

Frank Webb has strong views about his chosen profession, believing that, perhaps, after taking the baton from the English traditionalists, American painters have taken the watercolour medium to new frontiers of poetic expression. In his opinion some who favour oils have put down watercolour's reputation, as have some who use watercolour only for preliminary studies. These attitudes foster the impression that watercolour is a trivial medium, and major works of watercolour are correspondingly absent from the permanent collection of many art museums. Indeed collectors have been known, quite erroneously, to regard watercolour as less permanent. It is interesting to note, though, that some great institutions are collecting Frank Webb's own watercolours.

In his art he hopes to hand on these deep

MONTEREY – FISHERMENS WHARF ▷
This picture has the richness of a sunlit, stained-glass window. See how the wharf curves into the picture as it moves into the depth. It has an overall red colour dominance which gives it unity and the strong shadowed buildings provide the stability and strength, or the 'chassis', as Frank calls it.

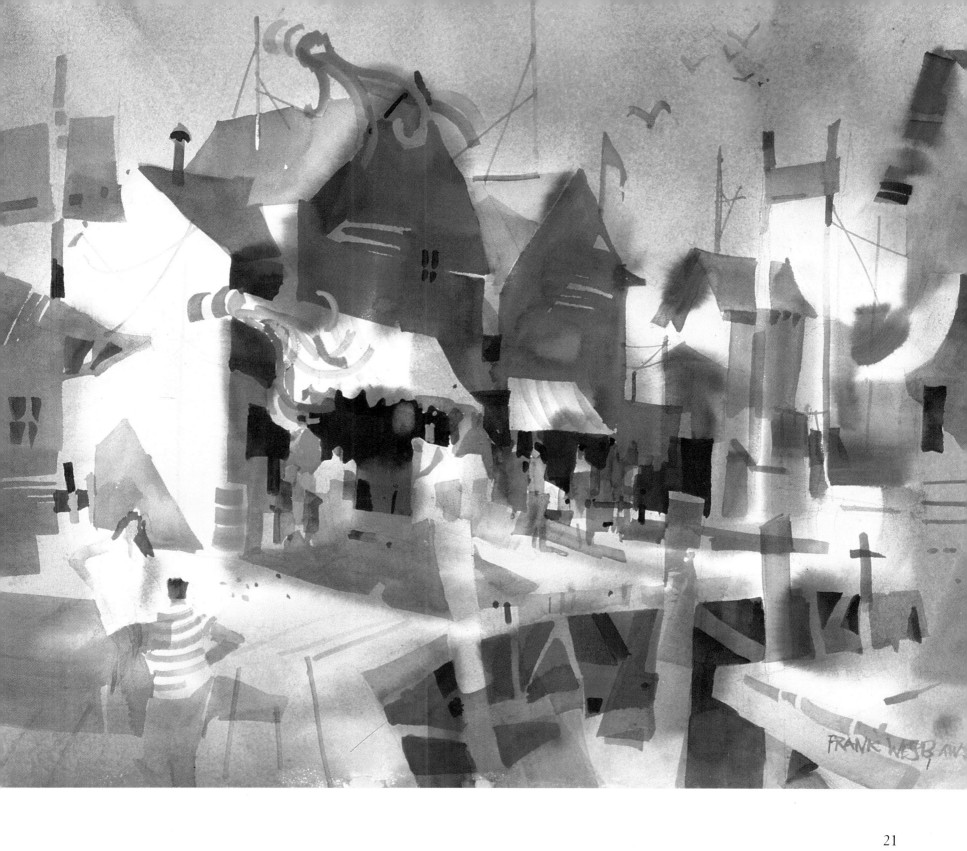

feelings to others. This requires a lot of knowledge – and a lot of paper. A large supply of paper to him is like having many tomorrows! Frank Webb ruins much paper in pursuit of excellence, but would always rather start a new sheet than rectify a bad start. For him the thrill is in the beginning and brevity his aim – he would do it in a single stroke if he could. 'Most people judge us by what we've done,' he says. 'We judge ourselves by what we think we should be able to make tomorrow.' He feels that the field of painting is so vast that one can only glimpse at its possibilities, 'We need to study nature, the palette, the paper and ourselves. As each area receives illuminating rays of new understanding, new challenges arise. My goal is to eliminate my ignorance.'

With his deeply philosophical nature and infinite capacity for hard work, Frank Webb is a man who is on course for achieving his ambitions.

OFF SALMON SEASON ▷
The subject is a construction used by fishermen to net salmon as they swim up the Columbia River in Northwest America. Frank has alternated warm and cool patches on damp paper, which he's used as a background for the strongly counterchanged construction.

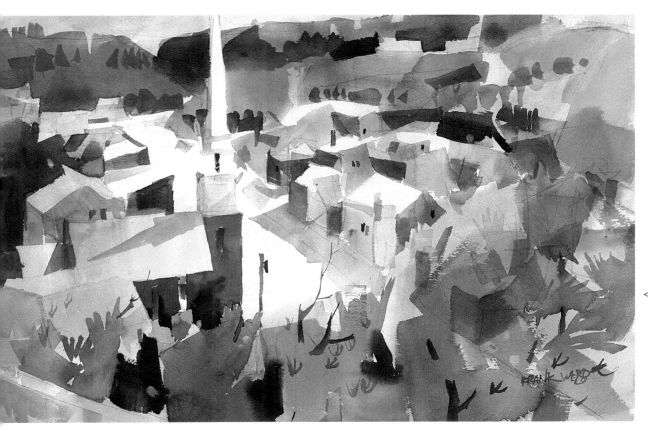

◁ TOWN OF GALENA
In this picture the town is grouped into a bowl shape. Although Frank said that when this was sketched there was no sunlight, he deliberately superimposed shadows to show a hypothetical sun at top right. The pale lavender underpainting in the foreground helps to qualify the greens of the foliage.

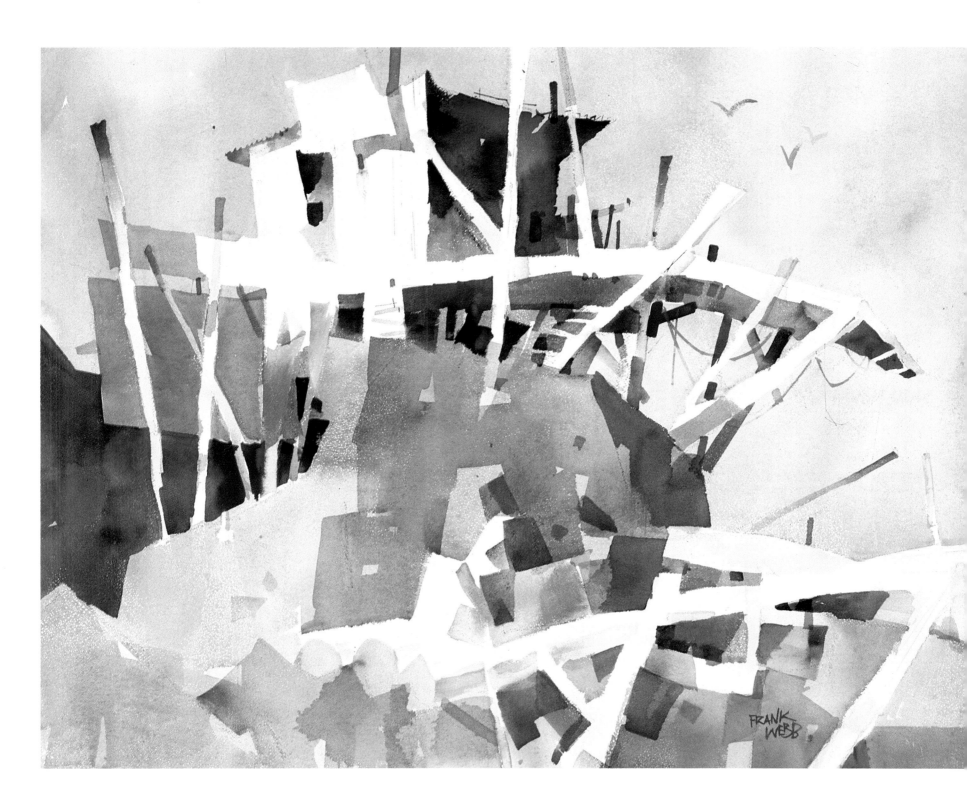

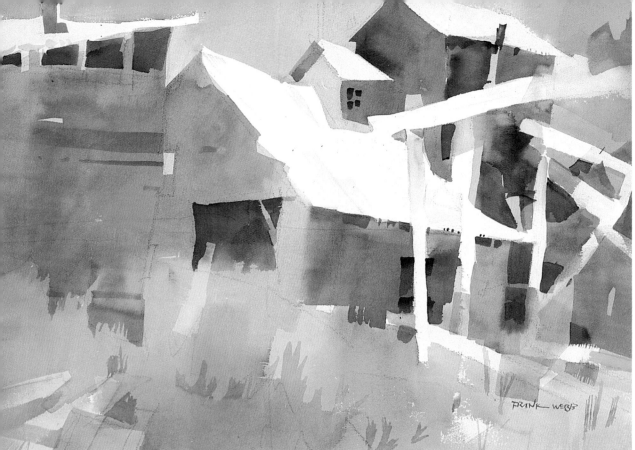

BILL'S LUMBERYARD

Here's a terrific contrast between the soft wet-into-wet blending of the foreground grass with the stark, staccato shape of the roofs and supports. There's some beautiful rich colour in the shadows of the buildings. Notice the strong overall diagonal pattern about the whole painting.

DECORAH FEED ▷

This is a grain mill in Iowa. Frank has painted this in two separate phases. First wet-into-wet, providing all the soft wet-edged values and, when this was dry, all the hard-edged calligraphy was added directly without alteration to preserve the superb overall transparency.

BEAR RUN AT FALLINGWATER ▷

This is a Pennsylvania mountain stream. The blue-colour dominance unifies the whole painting, while the three clearly separated values give readability.

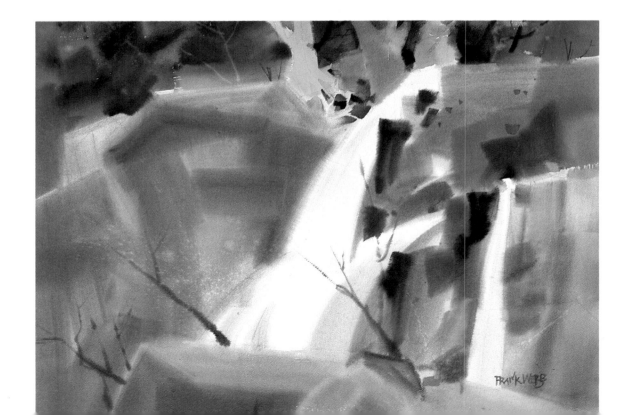

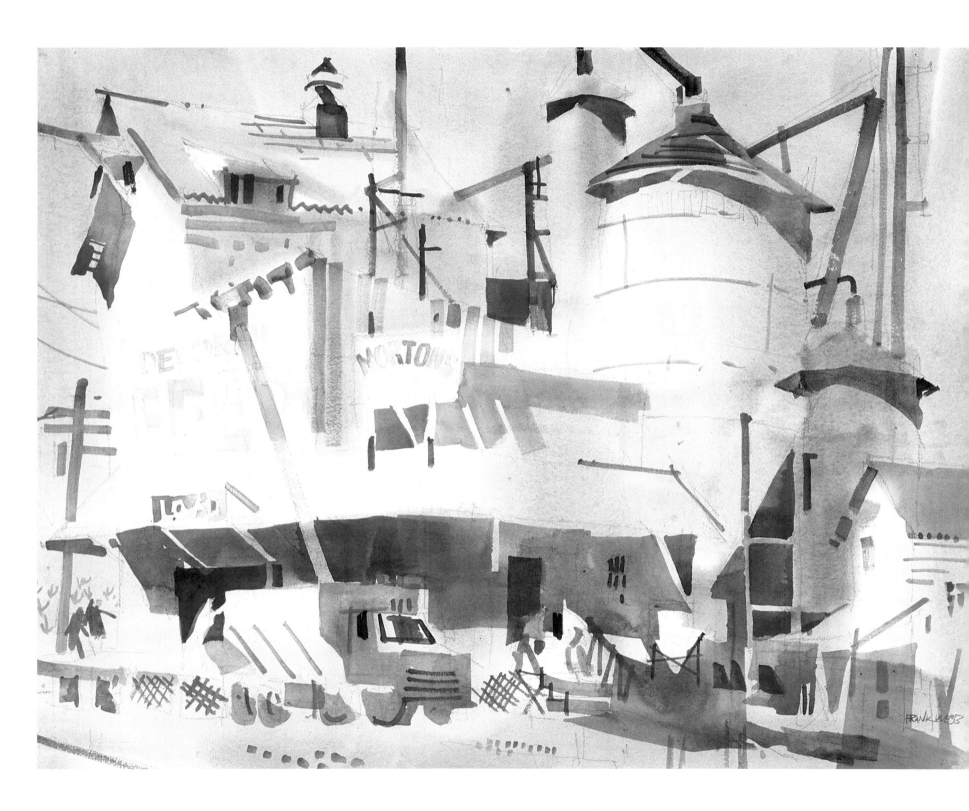

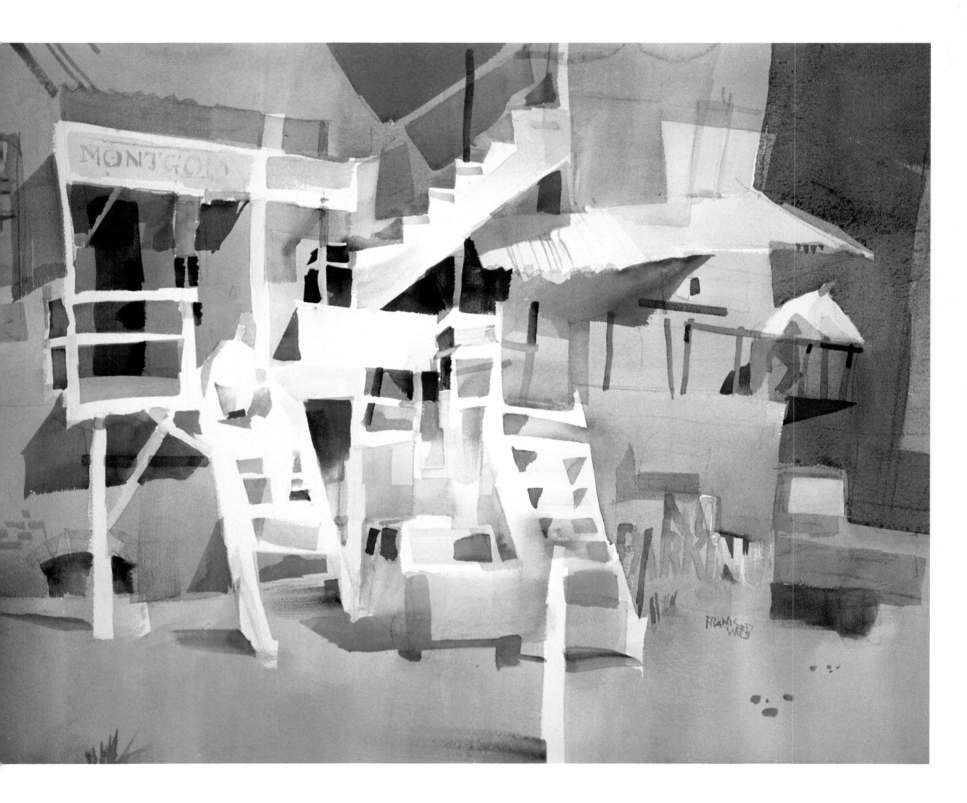

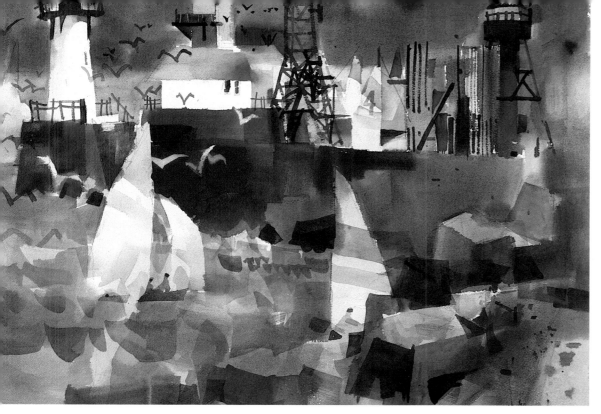

△ DULUTH HARBOUR
This is a dramatic painting of a port on the Great Lakes. There's a strong zigzag pattern to the picture, the eye being carried up the foreground rocks and then back along the dark wharf. There's a wealth of rich colour in the blues and purples. The counterchanged birds provide a lot of movement too.

▽ RECLINING FIGURE
I've included this because it's interesting to see how Frank has adapted his normal staccato style to portray a soft feminine figure. The flesh glows with soft blended colours counterchanged against the dark blue shadow. It was painted from life at an evening life-group.

◁ BACK STAIRS
This is a typical example of the way Frank creates a linked pattern of white and dark shapes superimposed on a soft transparent carpet of colour. One of the dominant strengths of his work is the complete unity of his paintings.

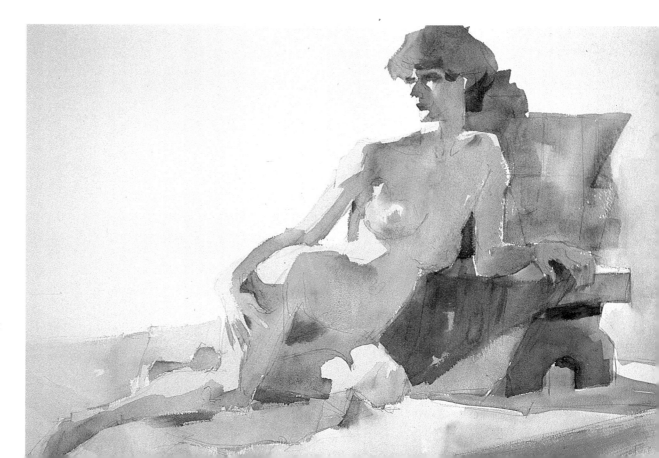

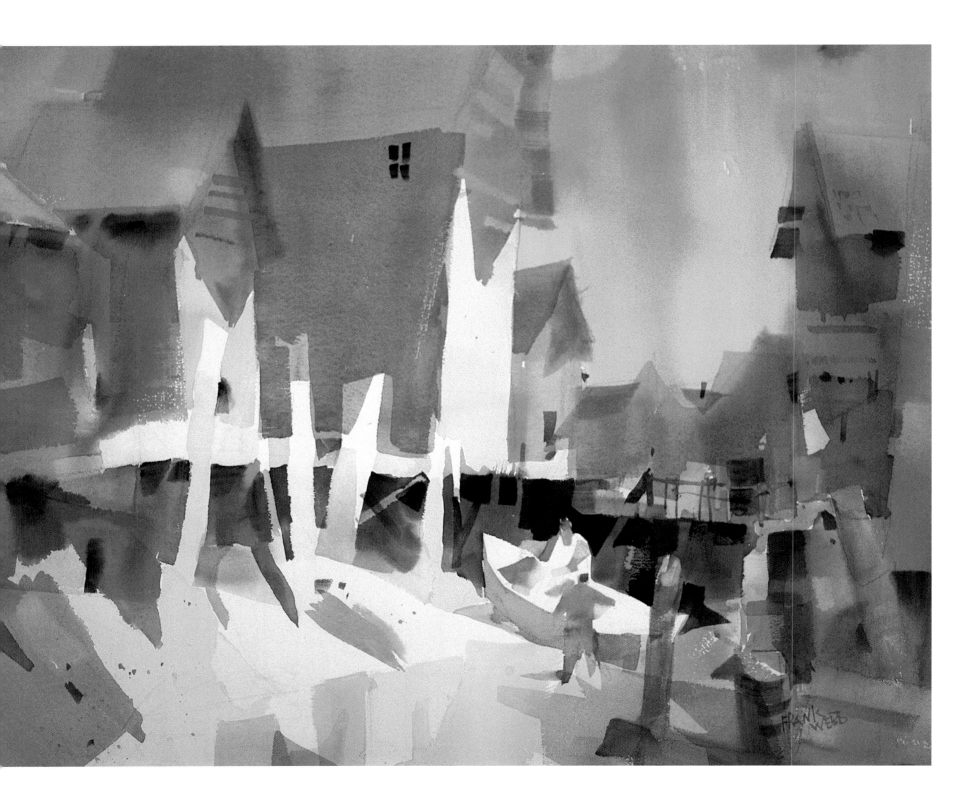

◁ DOCK SQUARE
This was painted from an on-the-spot drawing in Maine. There's an overall golden glow about this picture. It holds together the central pattern of contrast between lights and darks of the dock and background building.

△ TAXCO MARKET
This is a very much softer, calmer and more gentle picture than usual in Frank's paintings. The pattern of pastel shades eventually leads the eye round to the figures ending at the dark patch of green and black.

◁ MISSOURI RIVER
This landscape was painted on location in North Dakota. The large white shape of the river was deliberately created, as are most of Frank's values, colours, edges and textures. Notice how the strongest darks and brightest colours are grouped around this white shape, with the rest of the picture being kept relatively subdued.

Edward Seago

It seems strange and a little difficult, to be writing a single chapter about a man on whom you've already produced a whole book. However, I make no apology for including him – so far as I'm concerned, he's the epitome of a Watercolour Impressionist. He is an artist's artist. He's had an incredible influence on me, and worldwide so many artists, from Edward Wesson to Don Stone, tell a similar story – they all speak of him with enormous respect and admiration.

During his lifetime his numerous one-man shows everywhere, whether in Johannesburg, Tokyo or Toronto, were sell-outs. His annual exhibitions in London each autumn were legendary, with people queuing all night for a chance to buy one of his paintings. What happened, eventually, was that numbered catalogues were issued when the doors opened at 9.00 a.m. and each holder was allowed to purchase only one painting.

Those exhibitions proved too successful for the critics, who turned their backs on them and stayed away in droves.

Edward Seago was born in Norwich in 1910 and throughout his life was dogged by a strange heart complaint which left doctors baffled. Because of this, his formal education was almost non-existent, but he spent his time at home pursuing his obsession – painting. By the time he was ten years old he knew he could never be anything else but a painter. Even when confined to bed, he still painted skies over and over again. At nineteen he had his first exhibition in Bond Street, which proved a great success. A year later one of his pictures was accepted for the Royal Academy Summer Exhibition.

Soon after this he began to travel with a circus, painting furiously and capturing every aspect of circus life.

He next gave his attention to ballet, attending performances almost nightly and sketching almost incessantly at rehearsals. He combined this with a tremendous output of equestrian paintings.

During the war, while a Camouflage Officer he, as a mere Major, became close friend and painting companion to General Alexander. Unfortunately the Army then discovered his heart condition and discharged him. Within days, though, he'd persuaded General Alexander to make him his official artist. The General provided him with a jeep and an orderly and Seago spent the rest of the war painting the Italian Campaign.

After the war he started his regular Bond Street exhibitions and from then on his success was assured. He gained the friendship and respect of the highest in the land, including members of the Royal Family.

Back in Norfolk he revived an old interest in boats and sailing and would voyage, on his own craft, from the end of his garden path to Paris and beyond, continuously painting. He began to travel further and further afield, through Europe and the Far East, providing himself with an increasingly wide range of subjects. He continued to work in this way until his sad death in 1974, from a brain tumour.

Seago followed a long tradition of English artists who believed that they should record what they saw. His technique brought out the essential character of the medium. The actual brush strokes or washes were never smoothed out but were left untouched and direct as a frank and honest statement of his craftsmanship – the means of application were stressed rather than disguised.

Other artists who, I hope, will study these pictures should be warned of an important point. The directness with which his paintings were executed makes them look decep-

THE POOL IN WINTER ▷
This I believe to be the definitive Edward Seago. All its attributes are admirable. He has used a minimal number of strokes and yet has managed to convey a tremendous atmosphere of utter peace and tranquillity. This was painted at the bottom of his garden in Ludham. (Courtesy of Richard Green)

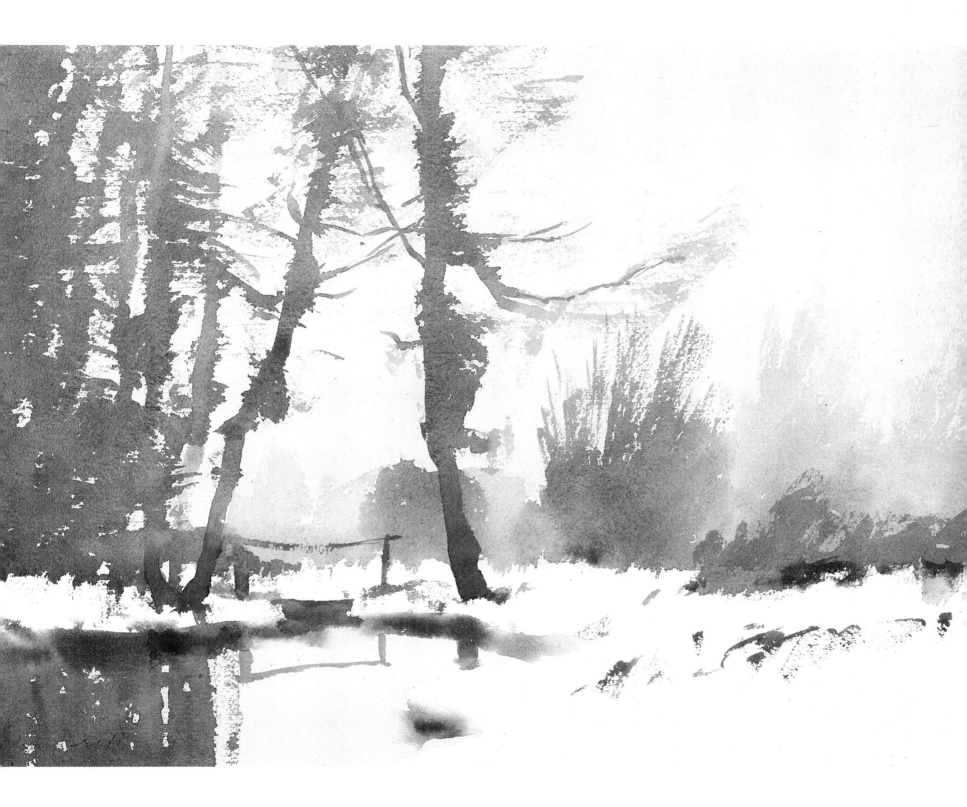

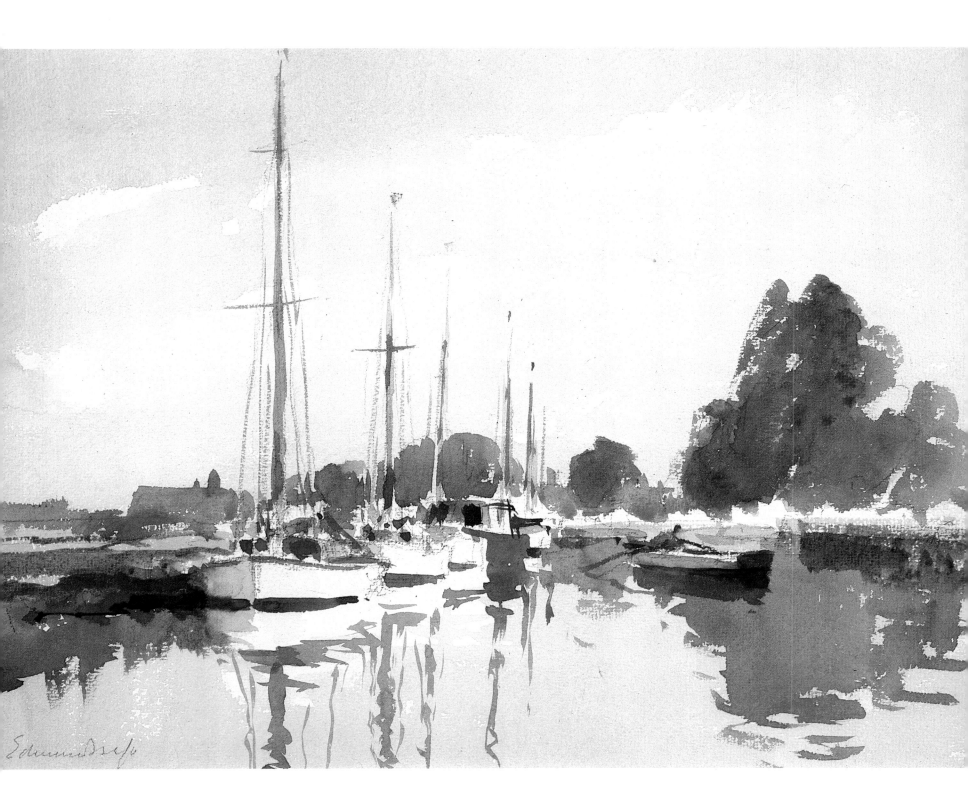

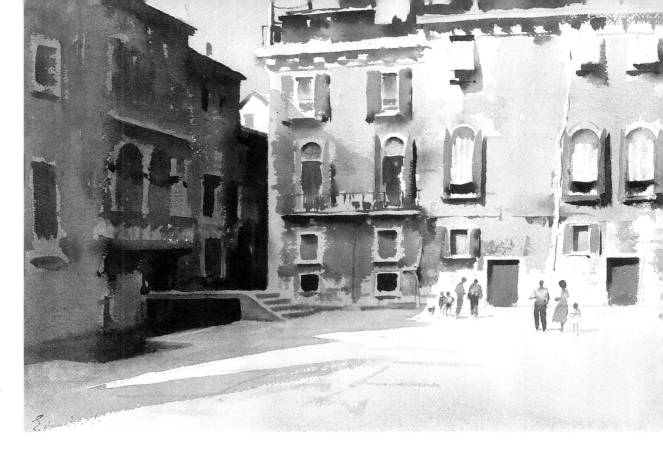

◁ SEPTEMBER EVENING
This is another familiar spot as it's where I often used to moor my yacht overnight. The scene is evocative of boats safely moored up after a good day's sailing, and the scent of supper cooking in the air while the children potter about in dinghies. The reflections are a very important part of the painting, providing much of the atmosphere.
(Courtesy of Richard Green)

tively simple. That directness is only available by rigid self-discipline and sound craftsmanship – there are no short cuts to excellence!

Prince Charles wrote of him, 'Whatever the so-called experts say, Edward Seago's gifts will long be remembered, valued and loved. His work was in the best tradition of that peculiarly English school of landscape artists with which few others can compare.'

△ S. VIDAL
The thing that strikes you first about this painting is the warm sunlit colours on the walls and the deep shadows that convey so well a Venetian evening. Edward Seago was able to convey so much of the character of each tiny figure with a few apparently casual strokes of his brush.
(Courtesy of Spinks)

◁ THE BEACH AT CALA DI VOLPE
This is a classical example of a composition that has been designed to take the eye into the picture. The device he used, of course, is the zigzag. Look also at the way he cooled down the colour of the beach as it recedes, using the same device on the three layers of rocks.
(Courtesy of Thomas Gibson)

STORM CLOUDS OVER WINDSOR ▷
*Here is a beautiful example of counterchange –
the profile of the sunlit Windsor Castle standing
out against the storm clouds. It's also set into the
distance by the placing of the dark trees and
their reflections in front of it. There's a
particularly rich wet-into-wet sky with the
darkest clouds balancing the trees opposite.*
(Courtesy of Richard Green)

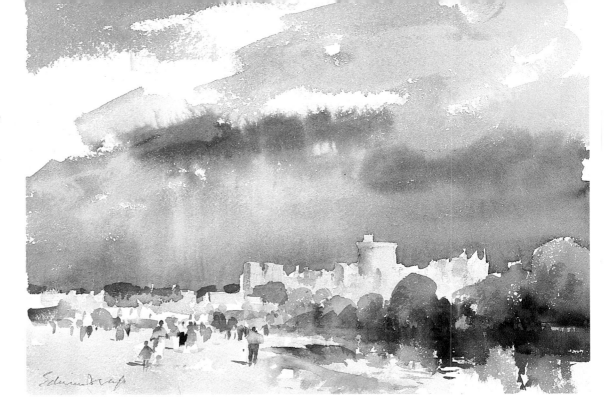

◁ THE TALL HOUSE, PARK LANE
*This picture has lots of different elements –
buildings, trees, people, even buses, all painted
in freshly and economically. It's a warm
picture, composed of mauves, pinks and greens.
Although the architecture of the building is
clearly shown, it has been indicated with the
minimum of strokes.*
(Courtesy of Richard Green)

A BEACH IN PORTUGAL ▷
*A deceptively simple painting with a wealth of
richly blended colour in the rock face. The
texture of the beach has been indicated with just
a few strokes, as has the breaking surf. It's
interesting to compare this beach painting with
that of Edward Wesson, himself a great admirer
of Seago, on page 93.*
(Courtesy of Thomas Gibson)

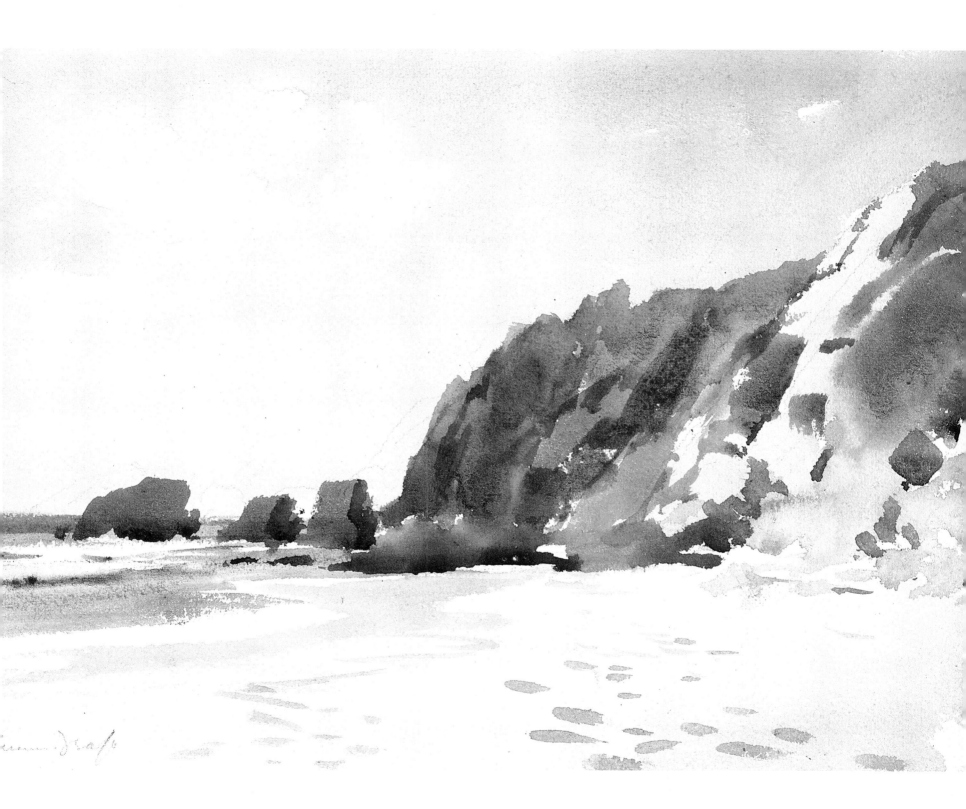

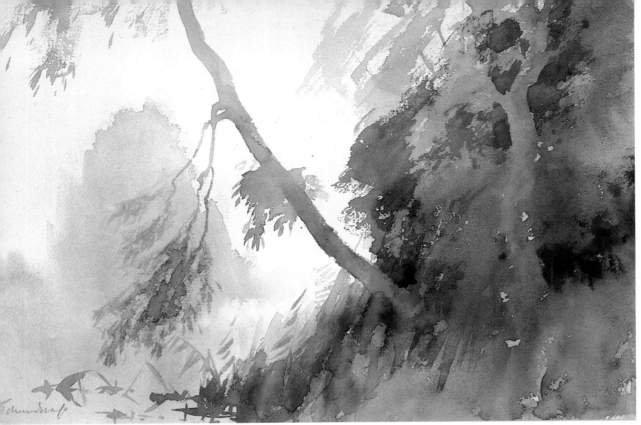

LOW TIDE, STRAND ON THE GREEN ▷
Edward Seago succeeded in giving a wonderful impression of early morning sunshine on the Thames. The purity of colour and the quality of light is breathtaking and, yet again, so much is left to the imagination.
(Courtesy of Richard Green).
By kind permission of His Grace the Duke of Westminster DL

▽ THE COLLEONE
There's drama here in the silhouette of the equestrian statue against the light sky – the picture is dominated by it but there's plenty of other interest in the Venetian architecture and the figures. Even for a Seago painting this is a minimal impression of such a complex scene.
(Courtesy of Thomas Gibson)

△ LEANING ASH TREE
This is a slightly unusual painting for Edward Seago, in that he used quite a lot of wet-into-wet in the distance – normally he painted washes on dry paper. Here it lends a fairylike quality to the distant sunlit tree. The various textures of the dark tree on the right have been skilfully executed. The leaning silhouette of a tree against a light background seems to have been a favourite device of his.
(Courtesy of Richard Green)

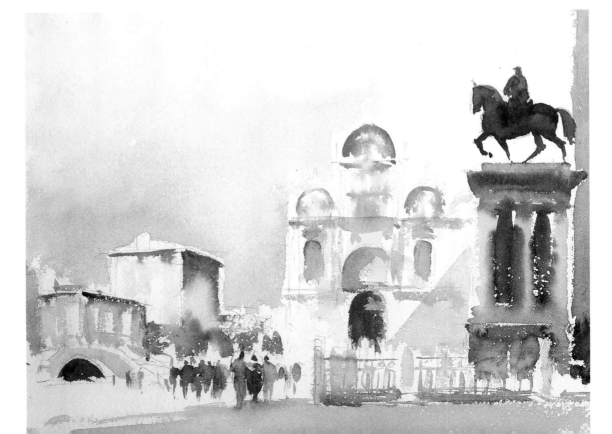

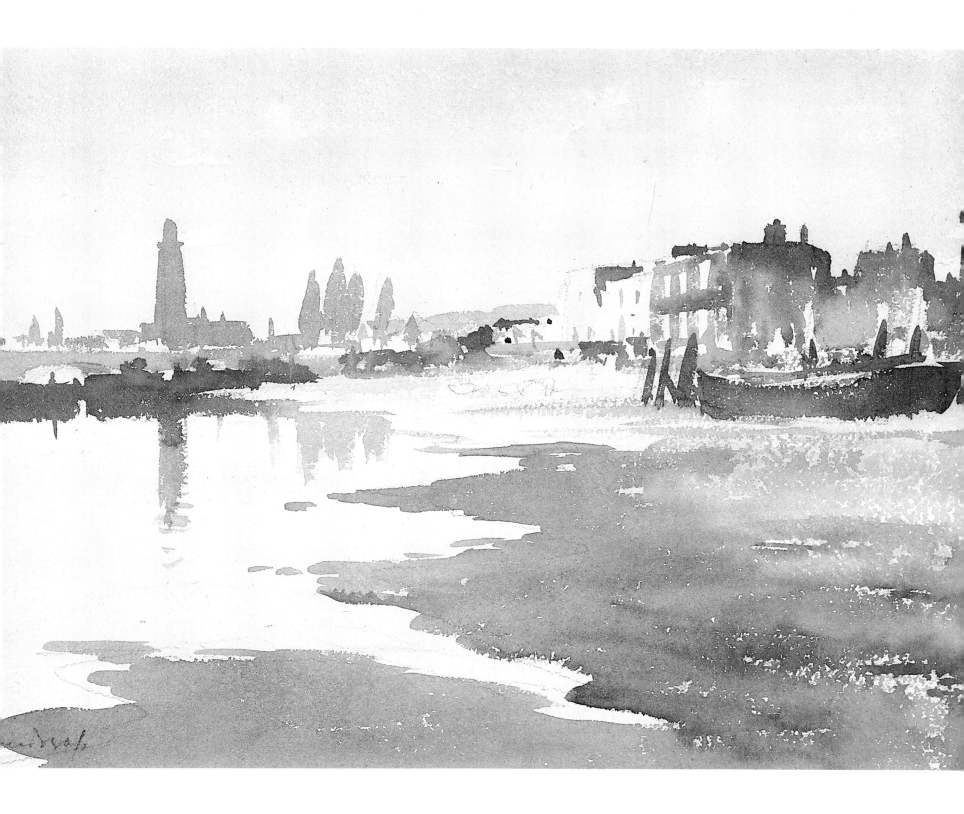

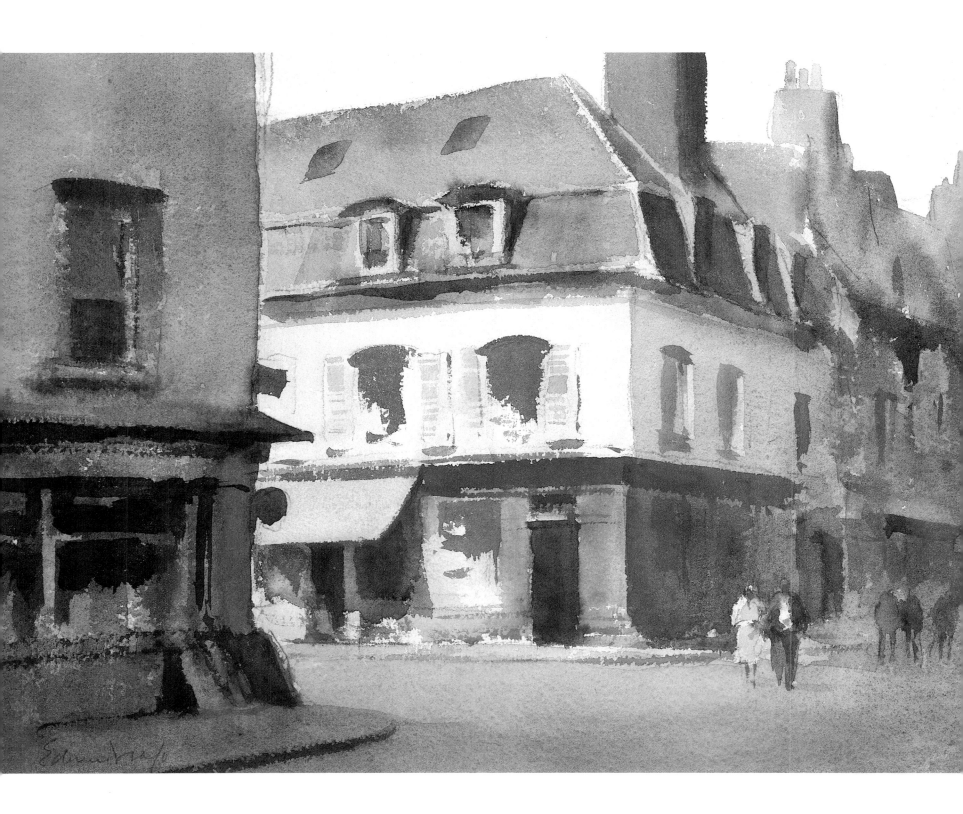

THE RED SHOP, DIEPPE

This is a superb example of a Seago street scene. The variety of colour in the shadows on the right is an absolute object lesson to thousands of artists who think of shadows as grey. The dark foreground shop on the left is also well worth studying. Look at the way its profile is dramatised against the light building and pink awning behind. I love, too, the effective touch of yellow on the woman's skirt.
(Courtesy of Thomas Gibson)

THE OLD FORT, PONZA ▷

While this is a very different painting from the one on the opposite page, the same device of a yellow skirt has been used here to provide a centre of interest. The sunlit profile of the fort against the blue sky has been painted in with the absolute minimum of detail – a touch of tone here and there and an odd pencil line is all that was necessary to provide the atmosphere.
(Courtesy of Thomas Gibson)

THE HOIST, PIN MILL HARD

Perhaps not the prettiest of subjects, but Edward Seago gave it atmosphere and dignity by surrounding it in a lovely pearly light. He put some subtle colours, too, in the skyline – mauve trees, pink/orange silhouettes of cottages – and yet again, that one touch of yellow in the near dinghy.
(Courtesy of Thomas Gibson)

39

John Yardley

'I'm afraid I haven't got a very exciting story to tell you,' he said, almost apologetically. I had come to meet him, this modest, almost self-effacing man, at his home in Reigate. Neatly dressed, courteous, with gold-rimmed glasses, one might have been forgiven for thinking one was meeting a solicitor rather than an artist, his only concession to unconventionality being a bow-tie.

He and his wife Brenda met me at the door and I was made welcome immediately. She is an attractive woman with a personality I warmed to straight away, and as a couple they were obviously happy and actively pleased with each other.

While she made coffee John told me about their way of life. They work together as a team – as well as keeping the books, she does most of the gardening. With a little help from John she has created a most artistically beautiful private garden; it features in John's paintings on page 42 and opposite the title page.

Over the past few years he has begun to paint flowers, giving them his own particular treatment, and they now account for just about a quarter of his output. Brenda also arranges the flowers for his paintings, 'so they don't look arranged', as John explained. The ones I saw were painted on tinted Canson paper which he had dry-mounted on card. He then uses a certain amount of white body-colour; an example is on page 41. He told me he had first been inspired to use this technique after reading Philip Jamison's book *Capturing Nature in Watercolour.*

Brenda also does all the decorating around the house, and evidence of her taste and personality is everywhere. They work for hours in the studio together, he painting while she cuts the mounts and photographs his painting for record purposes – an arrangement which certainly seems to provide a carefree, serene atmosphere for him to paint in.

John Yardley has been painting steadily in his spare time for about thirty years now; until recently he was working full-time in a bank. I got the feeling that this first career was followed more for the security it offered, rather than through a love of banking. It wasn't until 1986 at the age of fifty-three that he felt able to cut his links with the bank and become a full-time artist after an astute Bristol gallery had offered to take him under its protective wing as it were. John admitted

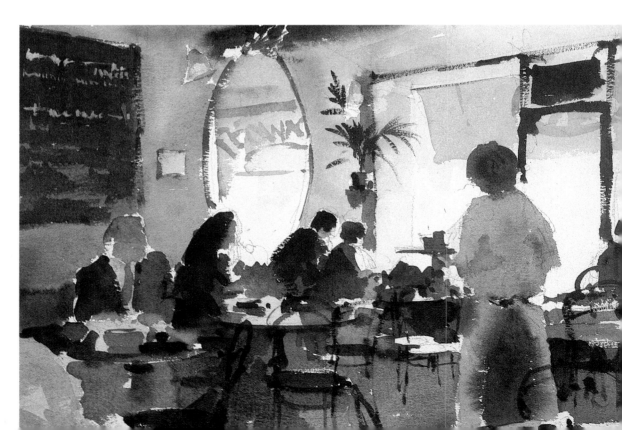

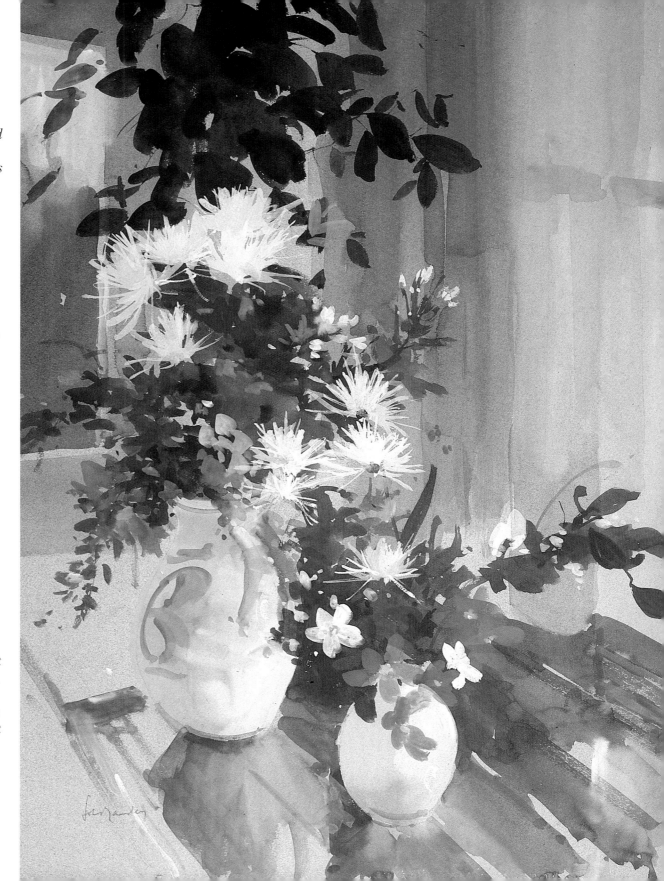

WISTERIA AND CHRYSANTHEMUMS ▷

This is one of John and Brenda's favourite flower paintings. She took it out of its frame on their stairs for me to take away and photograph. His flower pictures, on the whole, are painted in a different way from his landscapes. The grey dry-mounted Canson paper, which he uses, gives his work a particular quality, almost like pastel. The colour provides a unifying factor to the painting. This picture, which is full Imperial size (30" x 22"), has a very strong vertical design. The chrysanthemums are counterchanged against the dark foliage using cream body colour. The wisteria have also had white added to pick them out from the dark green. There is a great sense of almost careless looseness about the painting which is deceptively difficult to attain.

◁ THE OVAL MIRROR

This painting of Browns Restaurant in Oxford is all about light – the subdued, cool interior light contrasting with the glare from the street outside. The link is the silhouetted waitress, although even here light is bouncing on her from an unseen wall. It must have taken a lot of restraint not to have put any features on the face of the man on the left. The light in the mirror is emphasised by counterchanging the dark figures against it.

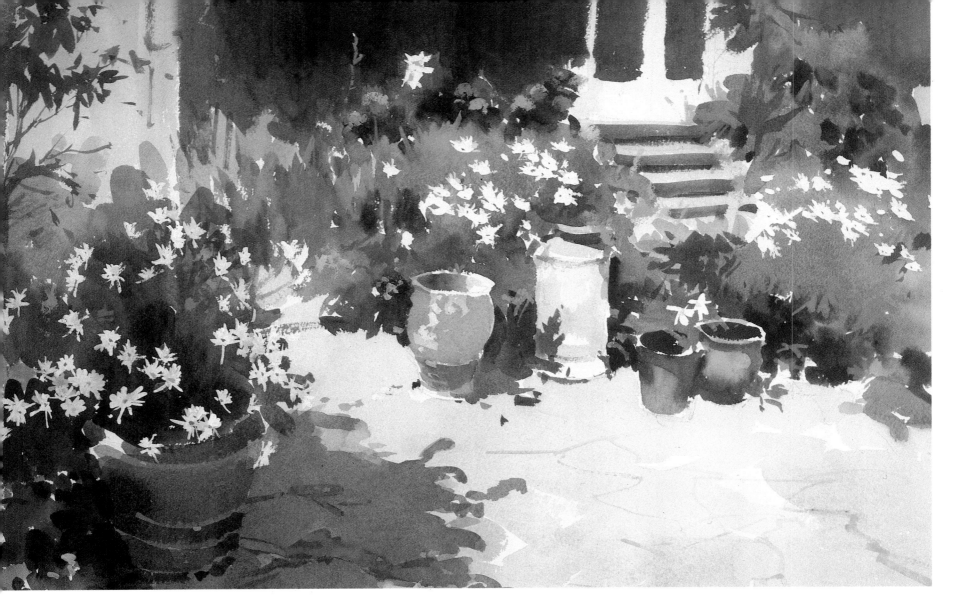

that in his earlier years, his technique and style were greatly influenced by Edward Wesson, who lived in nearby Guildford. However, since devoting himself entirely to painting two years ago, he had developed his own individualistic approach, technique, and range of subject matter, his popularity has taken off like a rocket, and I truly believe he will be recognised over the next few years as a great English watercolour painter. He is,

like Edward Seago, a painters' painter and it must give him a lot of pleasure to know that a great many of his paintings are bought by his fellow artists, as well as by knowledgeable collectors.

I was shown up into the studio, one of the upstairs bedrooms with absolutely no pretentions at all. No custom-made units or glass covered working surfaces here – it still says bedroom rather than studio – but once I

was inside I felt a tremendous sense of excitement. Finished paintings were everywhere and in various folders. Inevitably he had his little store of watercolour 'specials' – those he particularly liked and was saving for the big exhibitions like the RI. As we went through literally dozens of paintings I felt like a schoolboy let loose in a sweet shop, and picking out just about a dozen pictures was a difficult task.

◁ POTS ON THE TERRACE
This is a painting done in the Yardley garden
in Reigate. Counterchange abounds throughout
the picture – the white flowers against the dark
green painted with body colour, and the dark
leaves against the light patch, top left. The quiet
sunlit paved area is a foil to the busy activity in
the rest of the painting. A thoroughly satisfying
picture.

▽ WAITING FOR THE DINERS
I know this scene so well. It's the dining room
at Philipps House, a country mansion where
John Yardley and I both run painting courses.
One of the staff is obviously waiting for the 1
o'clock luncheon gong to sound. I love the way
in which the light from the window reflects on
the table, which is left as untouched paper. The
eye is drawn to the rich blue silhouetted figure
against the window. Notice the way even the
glasses are suggested. Though quickly indicated,
each object is authentic, from the period chairs
to the modern commercial food trolley.

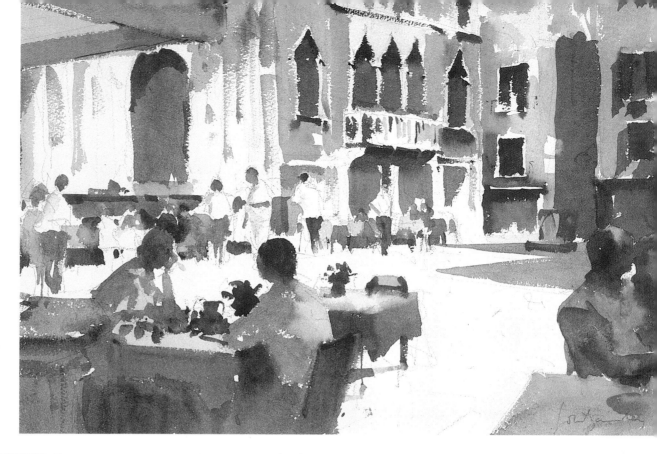

△ AT THE RESTORANT AL THEATRO
If you analyse this painting, over a third of it
is untouched white paper which forms a passage
through the design. One's eye enters the picture
between the two foreground tables and is drawn
into the sunlit square with all its staccato light
and dark shapes. So much of the distant figures
is left entirely to the imagination, with only an
occasional casual hint of the distant tables. The
adjacent walls of pink, yellow and fawn give a
lovely sense of richness to the architecture; the
ornate pillars, windows and balconies are left
to the observer to construct from the bare
impression.

43

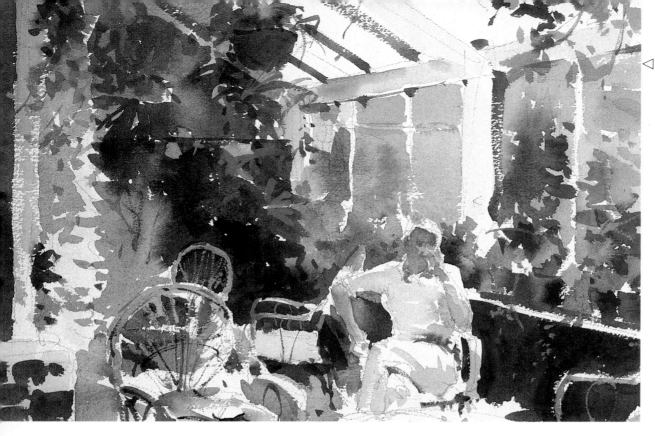

◁ TIME FOR A THOUGHT
A picture with a Sunday afternoon feel about it: a scene in a conservatory with plenty of contrasting lights and darks. One of many things I like about John Yardley's paintings is the sense of excitement this brings. The sunlit figure is highlighted by the surrounding tones while the strong light coming from above is emphasised by the dark hanging baskets. The wicker chairs are beautifully indicated.

CHIESA DEI GESUATI ▷
This lovely but complex church interior must have posed great problems in its simplification, but look, for instance, how the elaborate mosaic floor has been indicated by a few telling strokes with the side of the brush. So much is just hinted at – look at the reverent group around the crucifix – yet one can almost guess the age of the young man in front of the altar. The two foreground figures and the font play their part in giving depth to the picture.

Now to his materials. John's choice of colours is fairly conventional: blues include Ultramarine, Cobalt and Prussian; for browns he makes use of Burnt Umber, Burnt Sienna and Warm Sepia. The reds are Light Red and Cadmium Deep, and the yellows are Cadmium, Cadmium Lemon and Raw Sienna. His palette is a folding Robertson box, no longer available. (They don't seem to build palettes like they used to do. Most of the old craftsmen tinsmiths are gone now.)

John's real extravagance, if you can call it that, is his taste in brushes. Apart from a Rigger, most of the work is done in Winsor & Newton's No. 12, Series 7 – their very best quality range – which at the moment cost over £100 each. As soon as he feels it's losing its really fine point, which is usually about three months, he buys another one; the old ones lie all over the studio. I'm sure Winsor & Newton would argue about the longevity of their brushes, so it could be regarded as a minor extravagance on his part, but if new brushes help him to turn out pictures such as these, they are cheap at the price!

His other equipment is very modest. A portable metal Italian easel, of the type I use myself, and a wooden drawing board complete the equipment. His main choice of paper is Arches.

He also paints in oils and these are gradually claiming an increasing amount of attention, but one gets the feeling that his first love is still watercolour.

I came away after a day there with a happy excited feeling, partly because of the lovely paintings in the back of my car, but mainly because of the air of contentment and completeness that pervades that whole house. I'm sure it won't be my last visit to Reigate.

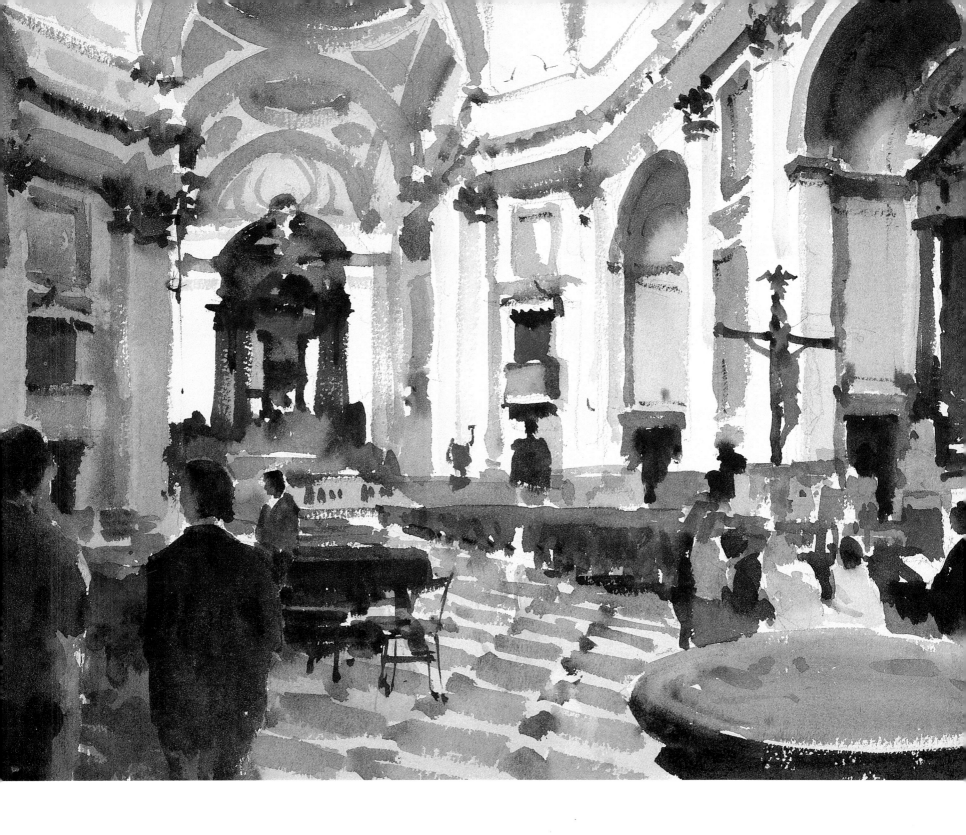

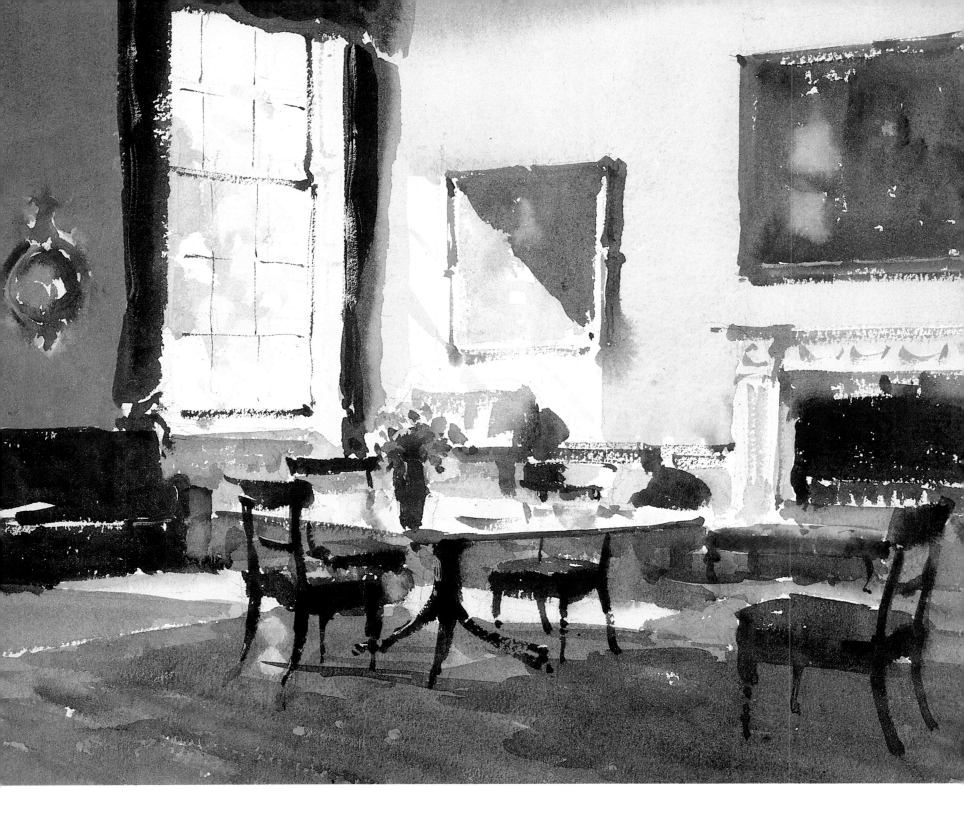

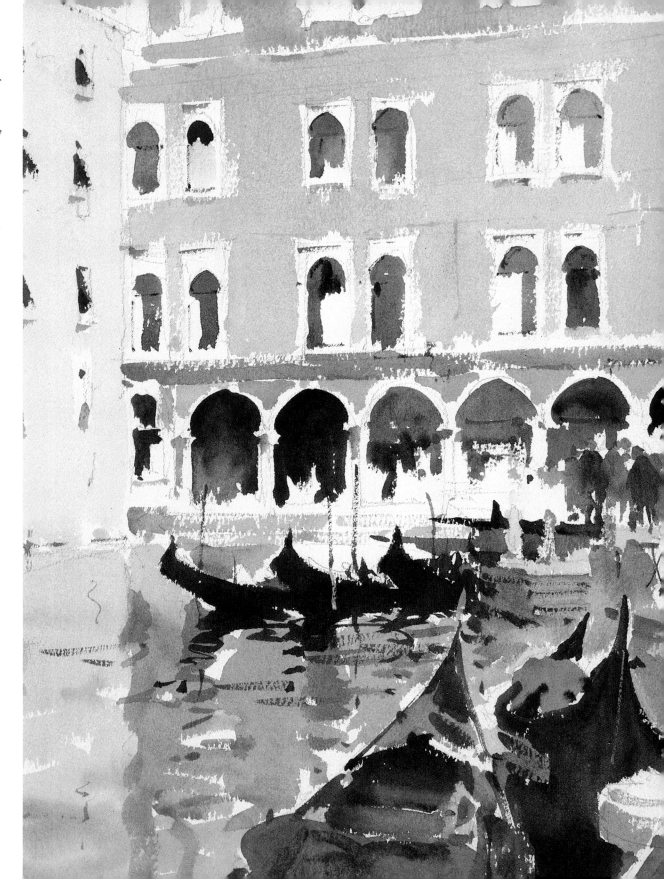

◁ THE SUNLIT ROOM

This is the library of Philipps House, another room of which is shown on page 43. One of the most exciting things about this picture is the way the period furniture is indicated with such clarity and brevity. One knows instinctively the exact nature of the curved mirror and the Adam fireplace. One's attention is drawn to the painting by the window, cut in half diagonally by the patch of sunlight on the wall. The shadow at the base of the picture holds the eye in and directs it towards the window, counterchanged against the dark curtains.

THE GONDOLA BASIN ▷

The tones of this picture graduate from the rich darks in the right hand foreground back to soft tones at the top of the buildings. The black profile of the three distant gondolas is emphasised by leaving a white untouched area behind it. It's a very restrained, almost monochromatic painting with only one patch of colour – the bright green tarpaulin cover – to attract the eye and become the focal point of the picture.

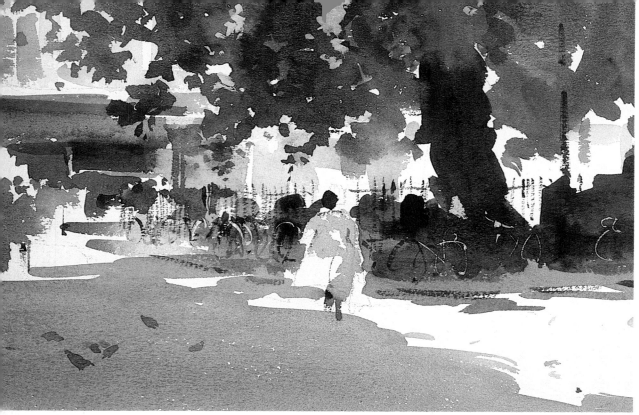

THE BENEFIT MATCH ▷

This painting is of a local cricket match in John's home town of Reigate. The second team is in as, judging by the long shadows, its's late afternoon. The painting has such a lovely curved flow to it, from the foreground chairs with the elderly couple past the two counterchanged figures to the main crowd of spectators, which are beautifully indicated. The solitary fieldsman on the boundary sets the scene. The left hand tree helps to balance the picture, as you'll see if you cover it up.

▽ RETURNING TO BARRACKS

I received a copy of this painting as a personal Christmas card from John and was so excited by it I felt it had to go in the book – he's managed to convey a tremendous sense of movement by keeping it loose and Impressionistic.

△ THE WHITE RAINCOAT

This is a superb example of Impressionism at its finest. The picture is all about the girl crossing the road in Oxford, with her raincoat casually slung across her shoulders. The whole shape and movement is conveyed by one quick stroke of the brush. The dozens of bicycles leaning up against the railings are an essential part of Oxford life, indicated by a few squiggles of body colour. The crowd of people on the left is also shown with masterly economy. A quick transparent shadow on the road is broken only by the feeding pigeons.

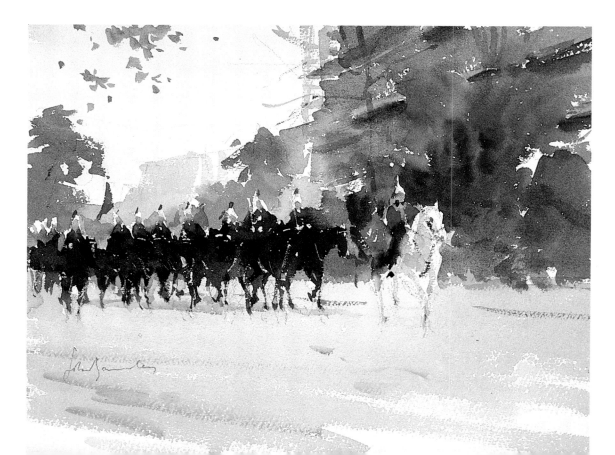

48

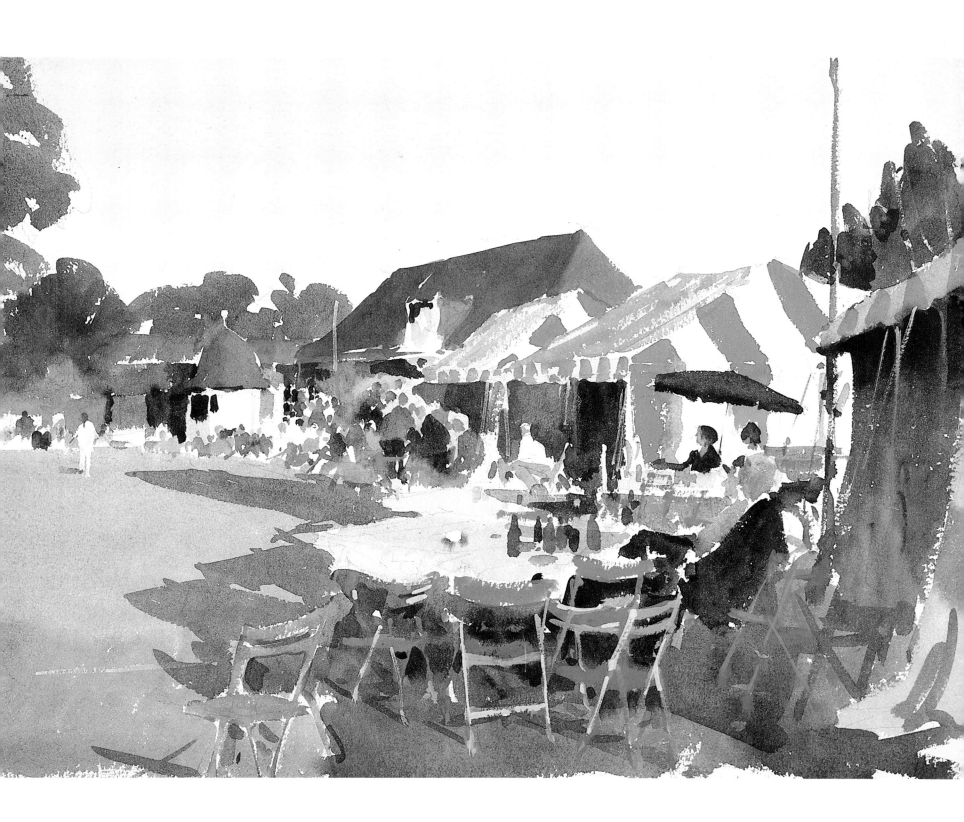

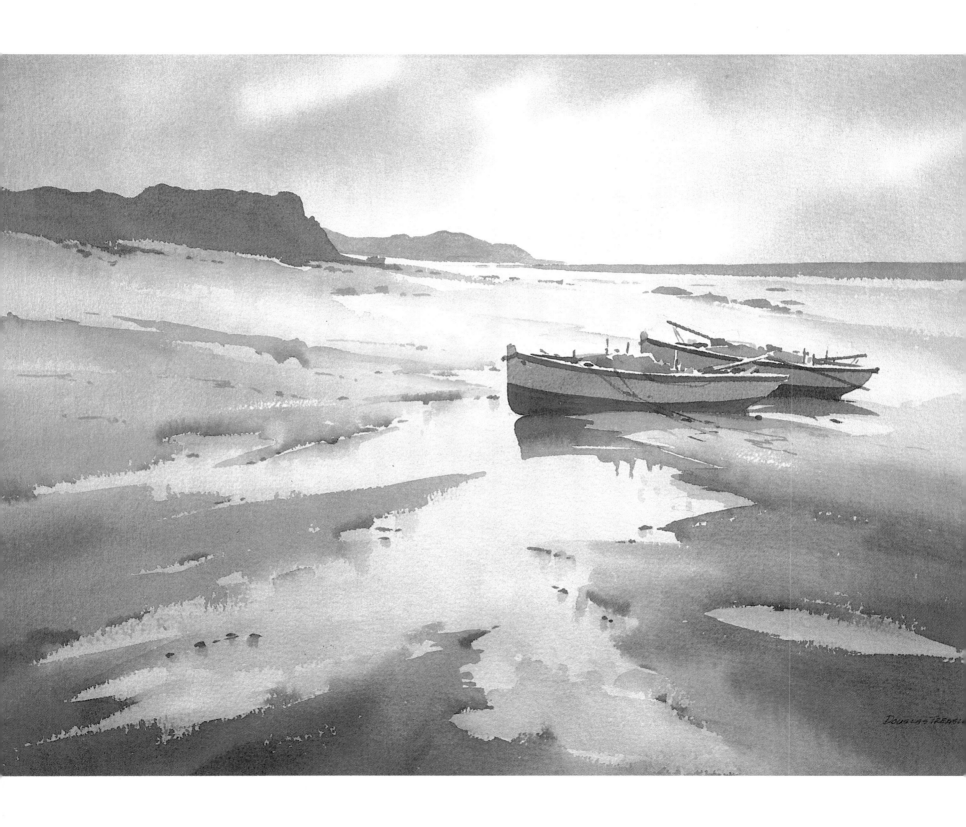

Douglas Treasure

Douglas Treasure

During my annual pilgrimage to the Royal Society of Painters in Watercolour Exhibition about four years ago, I was stopped in my tracks by the painting you see on the left. The treatment was so sure and direct and the composition so satisfying that I felt I had to buy it, and it has given me much pleasure ever since.

When completing the list of international artists for this book I felt that Douglas Treasure was the man to represent South Africa. Having visited the country twice on teaching trips, I could appreciate the way his paintings captured some of the spirit and atmosphere of this beautiful country.

Douglas was born in Cape Province of British parents and started drawing at a very early age. He was bitten by the 'painting bug' when he was given a tin box of watercolours. He says he still has a dozen or so 'paintings' done between the ages of eight and fifteen, but these, he says, are not for public viewing – only to be shown to very close friends!

After three happy and exciting years at The Port Elizabeth School of Art he became a junior artist with an advertising agency which, he said, gave him plenty of practical

◁ MNANDI BEACH

What attracted me first to this picture was the complete economy of stroke. Obviously a lot of thought went into this before each wash was laid. There's a great deal of depth in this painting – from the two distant headlands, each separated by tone and colour, the beach sweeps forward – the effect is obtained by changing the warmth and tone of the sand. The main object of interest, of course, is the two boats. Apart from them being darker than the rest of the painting, the eye is led to them by the foreground stretch of water.

BREE RIVER ▷

'This', says Douglas, 'was painted on a warm day in late summer under perfect conditions.' You can really feel the space in this picture. The whole painting is a gradual change of colour temperature from the warm, rich foreground to the cool airiness of the distant mountains. Look, too, at the counterchange of the dark trees against the light green grass.

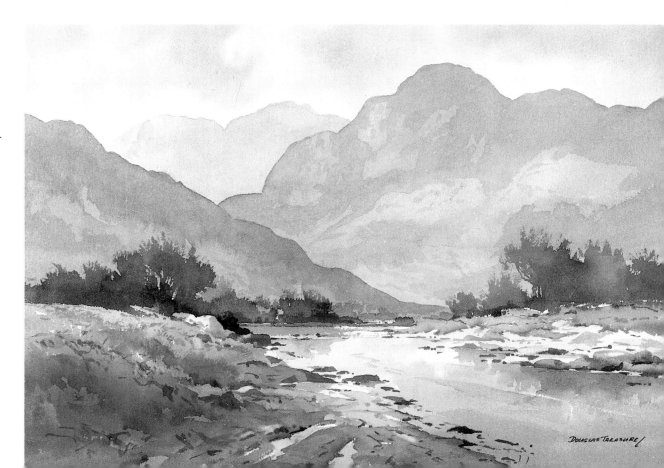

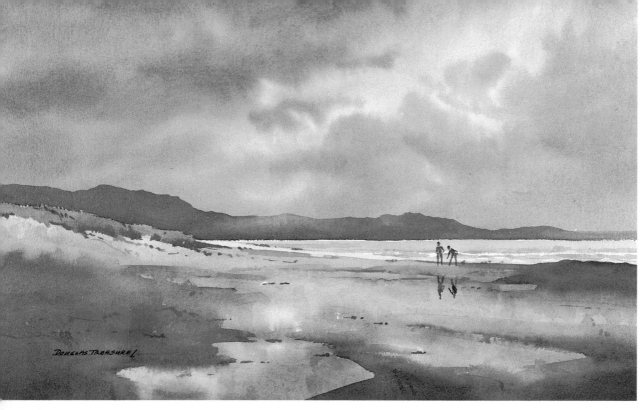

◁ EVENING – NOORDHOEK BEACH

This was painted on one of the Cape's longest beaches. It has a lovely warm evening sky that is reflected in the foreground pools. The figures and their reflections are an important part of the picture, lending scale and interest. I like the little patch of sunlight on the left that counterchanges the grass against the distant hills.

experience and discipline. Later, in Johannesburg, he worked as a package designer, free-lance cartoonist, and illustrator. In his spare time he continued to paint with a sketch club.

After the war he returned to advertising in Johannesburg, eventually becoming an art director, but always keeping up his painting. It was here too that he had his first one-man exhibition.

He next accepted an appointment in Cape Town and there he found his true environment – Douglas discovered that the Cape Peninsula was a painter's paradise providing him with a huge variety of subjects and bright mediterranean colours.

At 56 he retired from the advertising world to become a full-time professional painter, holding exhibitions of his work every two years.

Now that he is widowed and his children have left home, he lives in the town of Fish Hook on the coast, twenty miles from Cape Town, surrounded by mountains, sea and wine farms. These provide him with all the inspiration and subject matter he needs for his paintings. He still holds biennial exhibitions in Johannesburg.

He has had twenty-two one-man exhibitions, including one at the Mall Galleries in London; as mentioned earlier he also exhibits periodically at the Royal Institute of Painters in Watercolour. His work is in private collections all over the world as well as in various art galleries throughout South Africa.

Douglas has lived happily on the Cape coast for thirty-six years and says he has no desire ever to live anywhere else – the statement, surely, of a truly contented man. His work is a fine ambassador for his beautiful country.

ARNISTON ▷

This is a fishing village on the southern Cape coast. It was named after a British ship wrecked there in 1815. This is a really rich warm painting – you can almost feel the heat of the sunshine – but it is the foreground shadows that play an important part in the dramatic lighting of the cottages themselves. Notice the orange against blue in the right middle-distance.

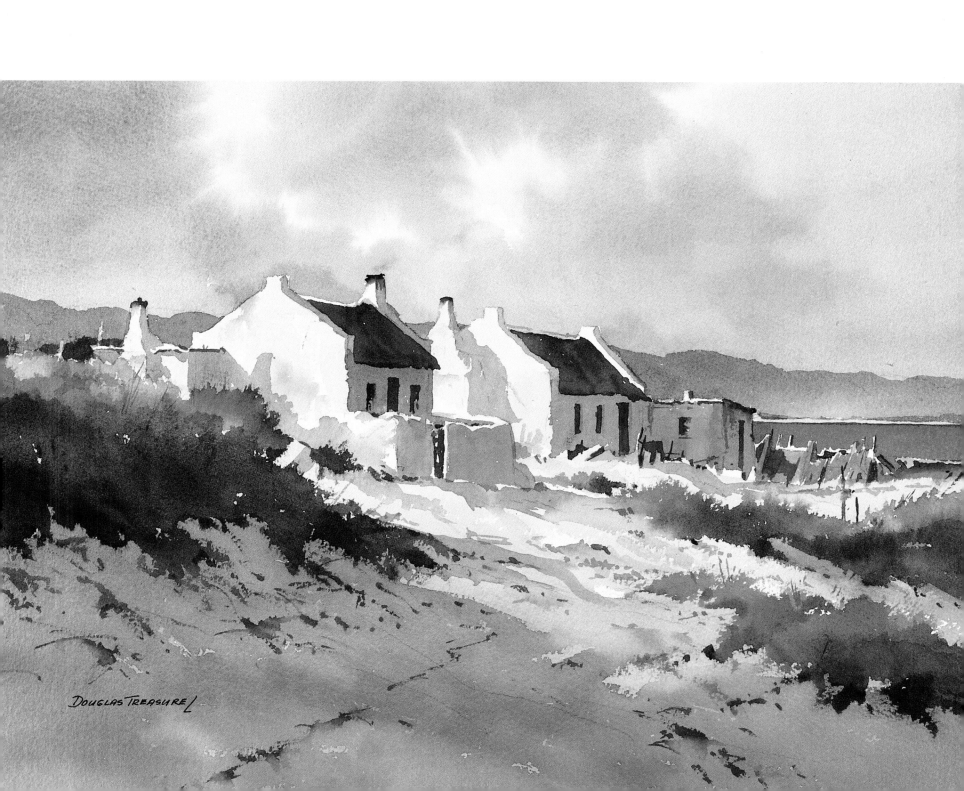

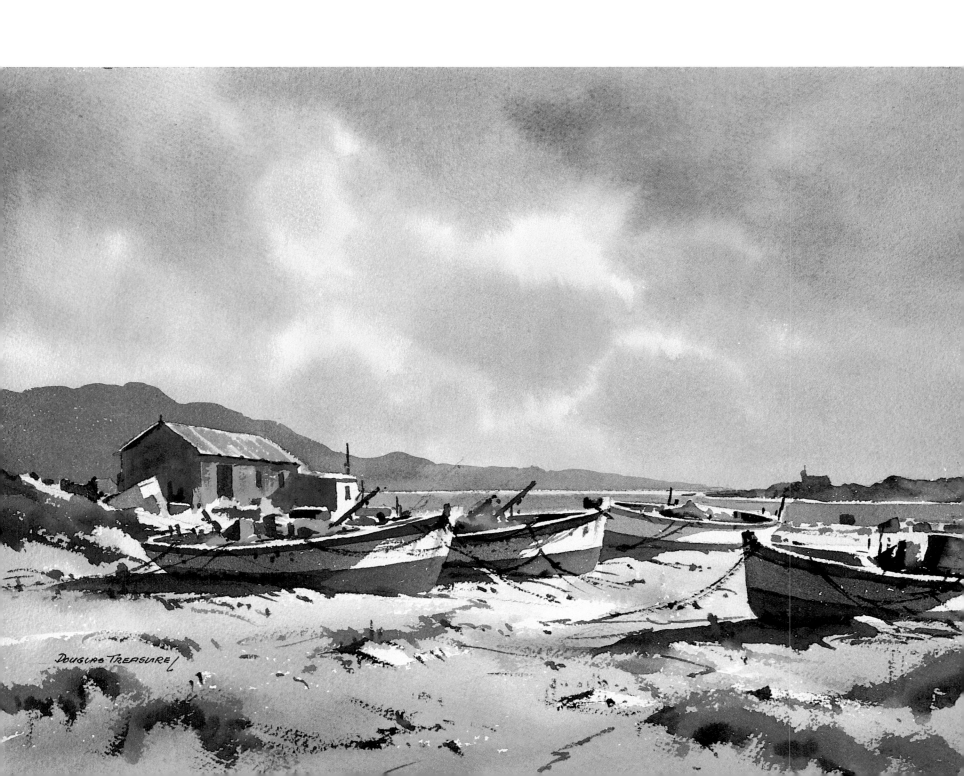

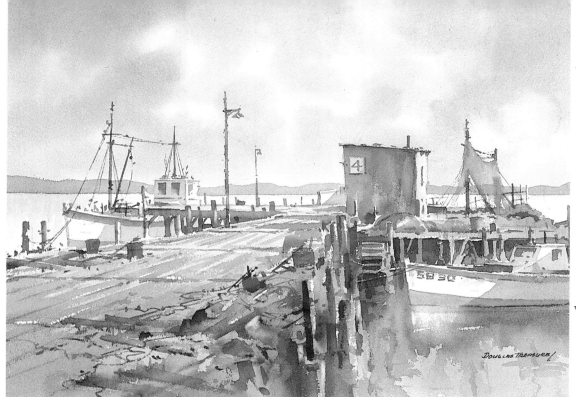

PIER 4, VELDDRIF
This is a fishing village on the north bank of the Berg River. It's a very paintable jumble of wood, piers, boats and fishing gear. This is a much cooler picture than normal. I like the way Douglas has handled the clutter in the middle foreground. The eye is taken along the pier to the end with its building and moored boats.

RAPIDS, BREEDE RIVER
This was a studio painting from a sketch made under very damp conditions. It's quite turbulent with movement both in the sky and in the water. There is also a very strong foreground here, with rich texture emphasising the light water.

LOBSTER BOATS, SOETWATER
'This,' said Douglas, 'was done on a bright day when the boats seemed purposely arranged to give a pleasing composition.' All the colour, contrast and interest is centred in one horizontal area with the sky and beach being deliberately sublimated. There's a large amount of counterchange amongst the boats and notice, also, how the profile of the hut is thrown up by the hills behind.

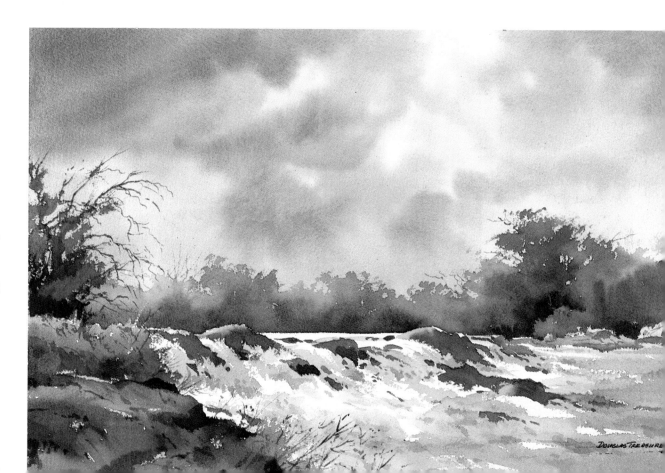

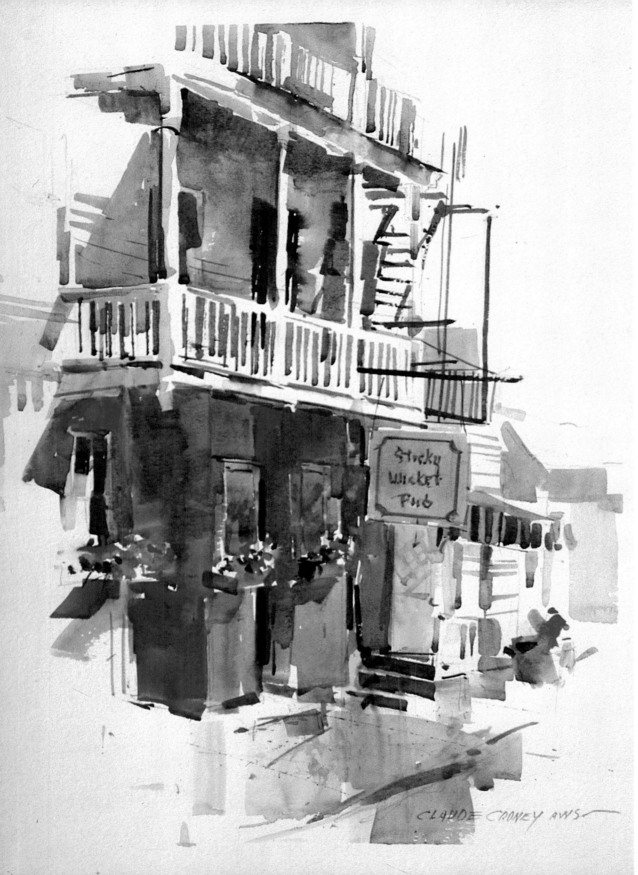

THE STICKY WICKET
This is a good example of effective use of cool and warm colour together – the rich browns and reds of the base with the cool greys above. Notice how Claude has used the untouched white paper for the verandah. The bright splashes of the flower boxes are also important.

Claude Croney AWS

One look at his paintings will show you that Claude Croney doesn't go for the conventional 'grand view' – the acceptable panoramas that are the stock-in-trade of so many artists. His confidence in himself allows him to see and paint whatever intrigues him, however mundane and unromantic the subject might be. In fact, he seems to revel in apparently unpaintable subjects – who would think of painting the inside of a saw mill or the back of a grain mill? There is a lesson here for those who waste hours wandering around looking for the perfect view.

However, his work is not all gritty realism either. He manages to bestow a dignity on his subjects, however sordid, by accentuating their underlying abstract design, and using soft focus and a blend of rich form and colour.

He usually takes between forty-five minutes and an hour and a half to complete these visual statements. Claude says of himself, 'I don't have the nature to be photographic because I'm too impatient. On a flat piece of paper I'm creating an impression of space or reality without detail. I want to be able to look at my paintings afterwards and say, I remember that boat, it was an interesting little accident – something I couldn't do again in a million years. It was just an impression of what I saw at the time.' This personal approach keeps his paintings looking fresh and spontaneous.

He hates to see watercolour overworked and works very quickly, although he is very aware that fast doesn't necessarily mean good. However, he uses just enough detail to complete the painting because he's really not interested in the detail for itself, but in 'a visual quick look – something that's happening just at that moment that will never be the same again.'

He spent a long time developing this approach. After all, he's been painting all his life – he says he was painting trucks with wheels in kindergarten when the other children were colouring in balloons! Later, as a teenager, he was just as interested, sitting up in the attic painting what he could see from the window; chimneys, roof tops and clothes lines, or down in the cellar painting coal bins, shovels or something with the light coming in around it – this explains quite a lot about his present painting.

Claude has spent his whole life earnestly pursuing artistic growth. His many students see this all the time because whilst he's always very encouraging to them, at the same time he is rarely satisfied with his own efforts. He has no favourite paintings of his own and doesn't keep any, feeling that his best pictures are still to come. Nor does he believe in resting on his laurels – he feels compelled to go on constantly producing paintings, striving to improve them.

He's an inspiring teacher and is always ready to pick up a brush to help someone out. His classes are mainly held out of doors and he usually manages to complete a painting of his own by the end of each session. He is a great advocate of outdoor painting. 'Studio paintings are all right, but outdoors you learn from nature and making your eyes work.' He delights in taking a class out to a lonely spot and saying, 'We'll paint here today'. The horrified students look round wildly for something to paint and while many can't see anything in such things as fences and an old dirt road, the few who do are a special joy to him.

Claude feels it only natural for students to start by trying to copy his quick, abstract style, but tells them just to keep on painting and, like their signature, eventually their own style will come through.

Later this year, while in Florida conducting a workshop, I look forward to visiting him at his home in Cedar Key. He himself conducts workshops, not only in various parts of the United States, but in nine other countries; he has also written three books. His work has received international recognition and has won more than fifty awards, including the Emily Goldsmith Award by the American Watercolour Society.

He believes that everything he does – the teaching, the workshops and most of all the paintings themselves – all 'relate to people' and personally I feel that this is something he does superbly well.

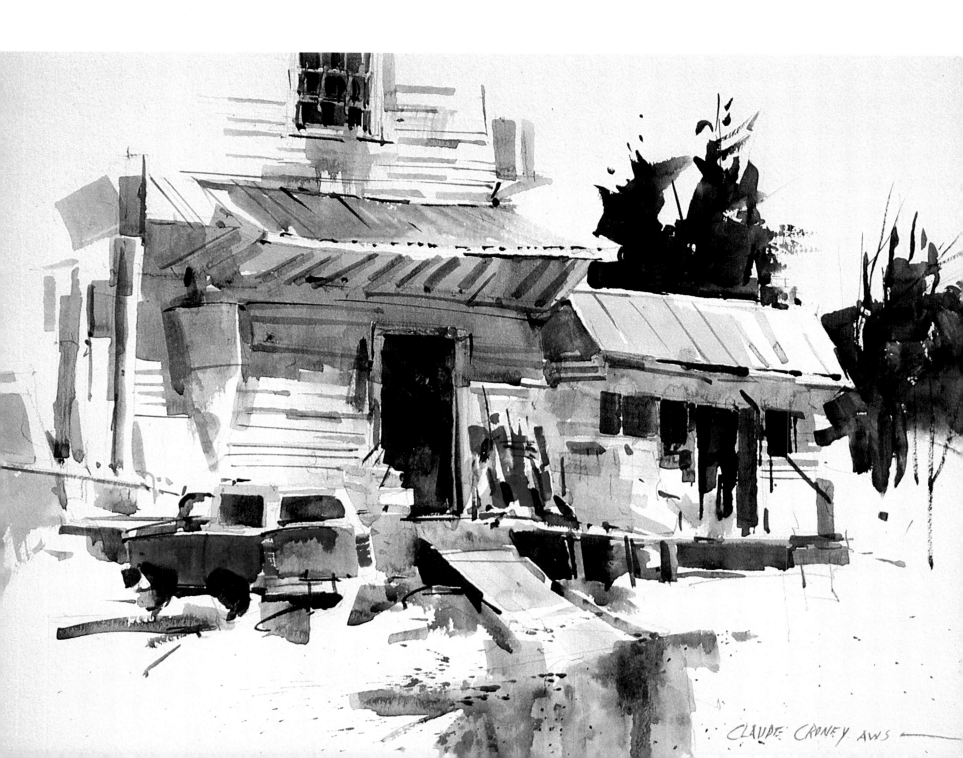

CLAUDE CRONEY AWS

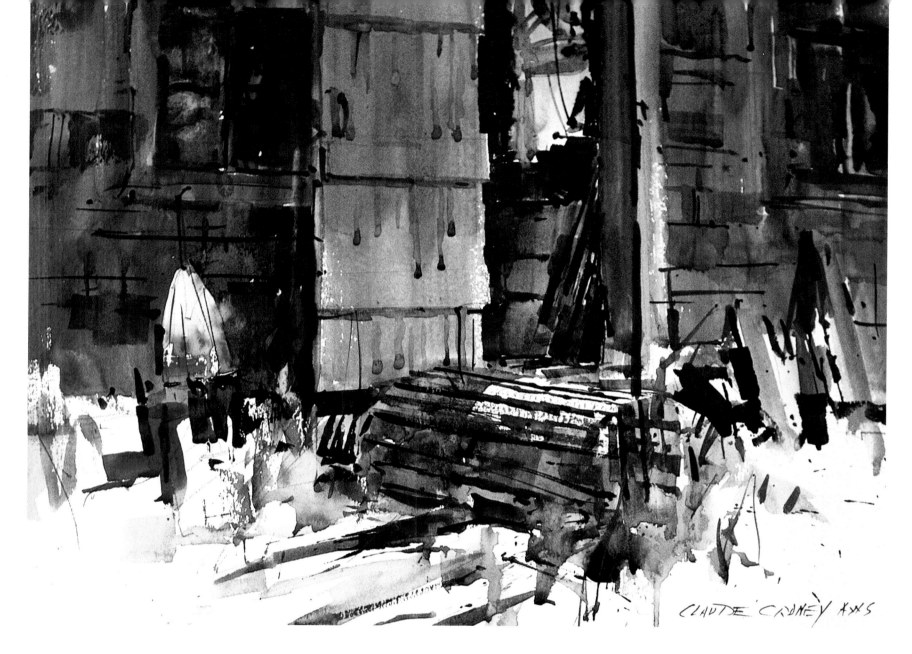

CLAUDE CRONEY AWS

◁ GRAIN MILL (Ohio)
*The main centre of interest is the open doorway,
and various means are used to draw one's eye to
it – the ramp leads to it, as also do the bright red
objects placed next to it. Notice, too, the
bouncing light in the shadows above the
doorway and the way the background trees pick
out the profile of the roofs.*

△ LOBSTER TRAP (Menemsha, Massachusetts)
*I like the patch of yellowy green light seen
through the doorway, which is echoed by the
two areas each side of the lobster trap. This
forms a triangle with the trap as its base. Look
at the way the profile of the door is picked out by
the dark recess. Overall there's a very strong
design element about this picture.*

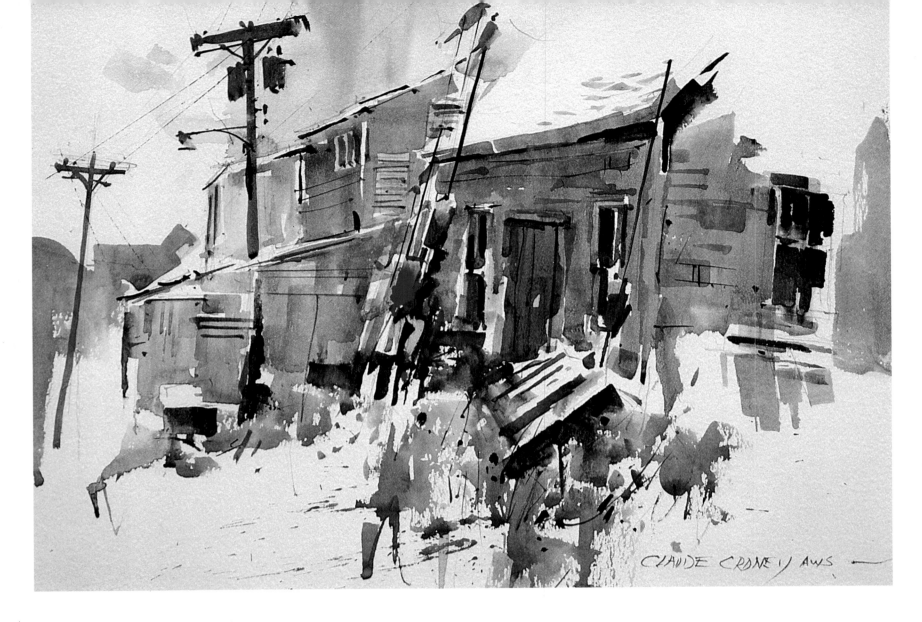

△ CAPTAIN POOLE'S SHED (Martha's

Vineyard, Massachusetts)

The red door is the centre of interest here. The
eye is caught, first by the bright contrasting
colours in the foreground of the picture, and
taken up the converging line to the door. Notice
how the colours on the left lessen in strength and
contrast so as not to distract the eye. The various
verticals are all placed at slightly different
angles to avoid monotony.

DAVIS FARM (Maryland) ▷
This is a very thoughtful and well designed
picture with the white snow area taking up two-
thirds of the space (half and half would have
been boring). The farm building, too, is just off
centre, and look how important the fence is in
taking the eye to it. Try covering it up and notice
how much of the impact is lost.

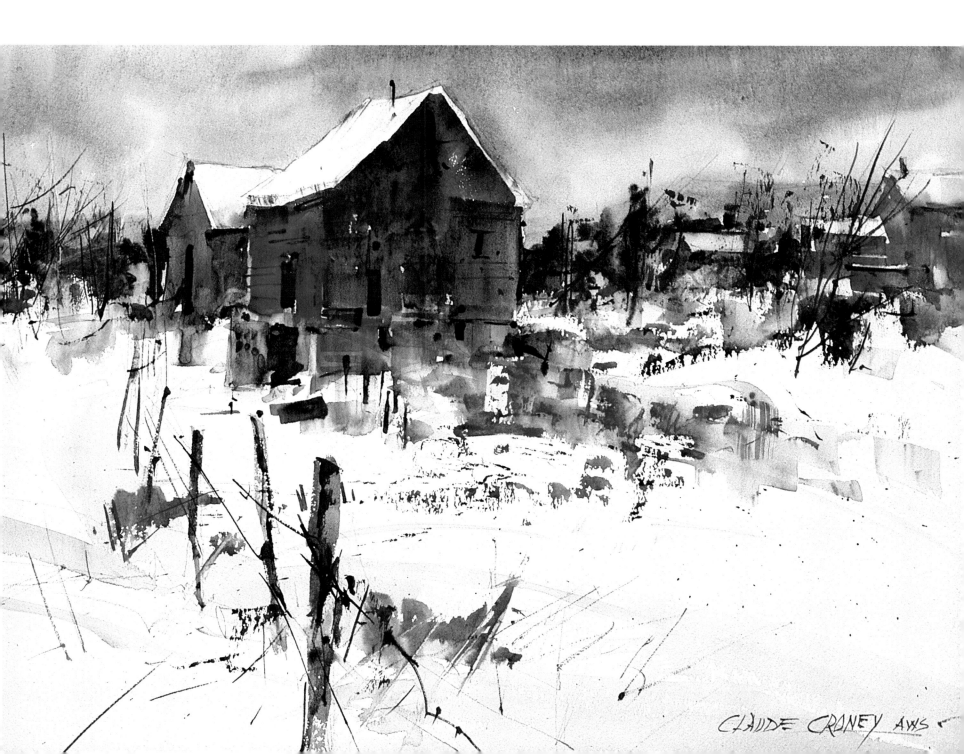

CLAUDE CRONEY AWS

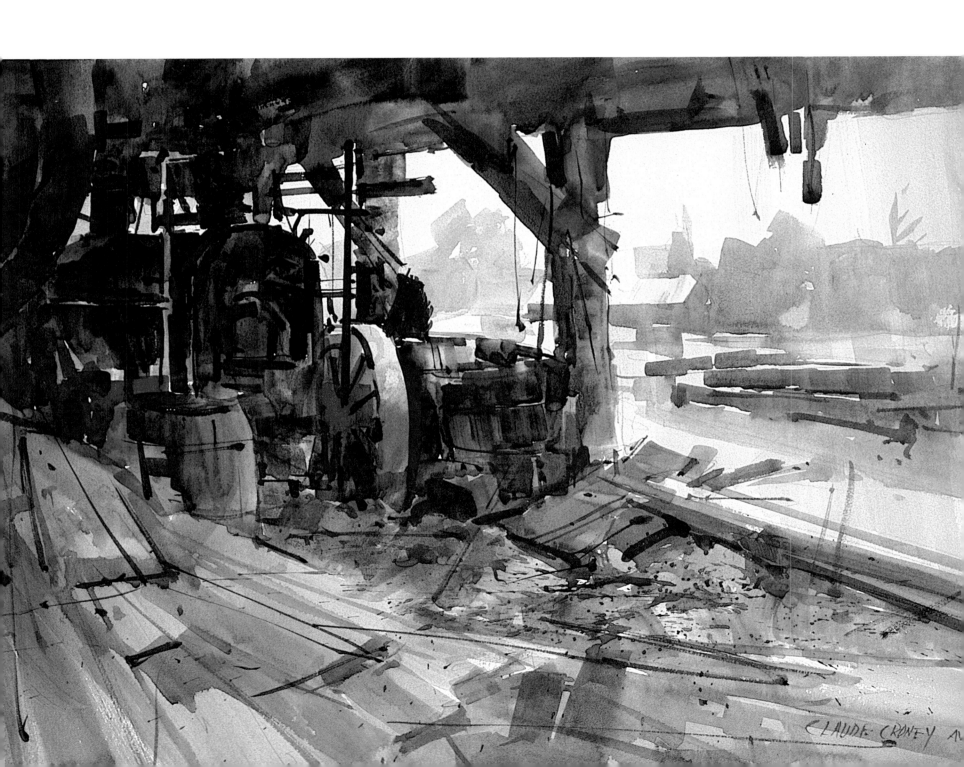

CLAUDE CRONEY

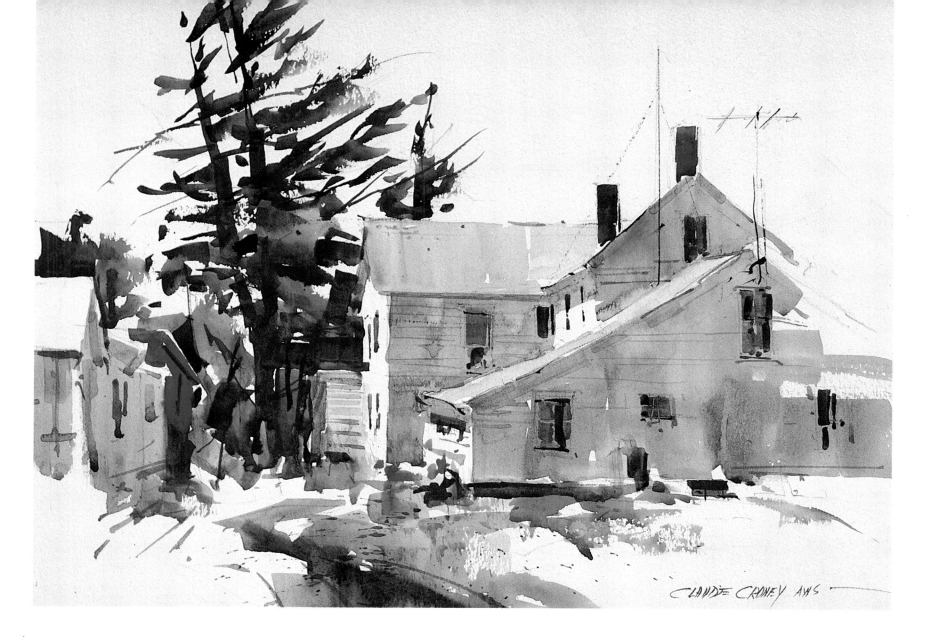

◁ SAWMILL (Ohio)

The flywheel is the centre of interest here. It is the area of greatest contrast and the most detail so that the eye automatically goes to it, while the distant view is subdued and just hinted at. There is a very strong flow of movement in the foreground made by the various angles of the planks. Note, too, how the feeling of sawdust is indicated by the splatter work.

△ WHITE HOUSE (Vermont)

All eyes are drawn immediately to the lovely rich patch of colour underneath the tree, which itself provides a good strong vertical element. The foreground path also leads to it. The White House itself contains a variety of subtle colour.

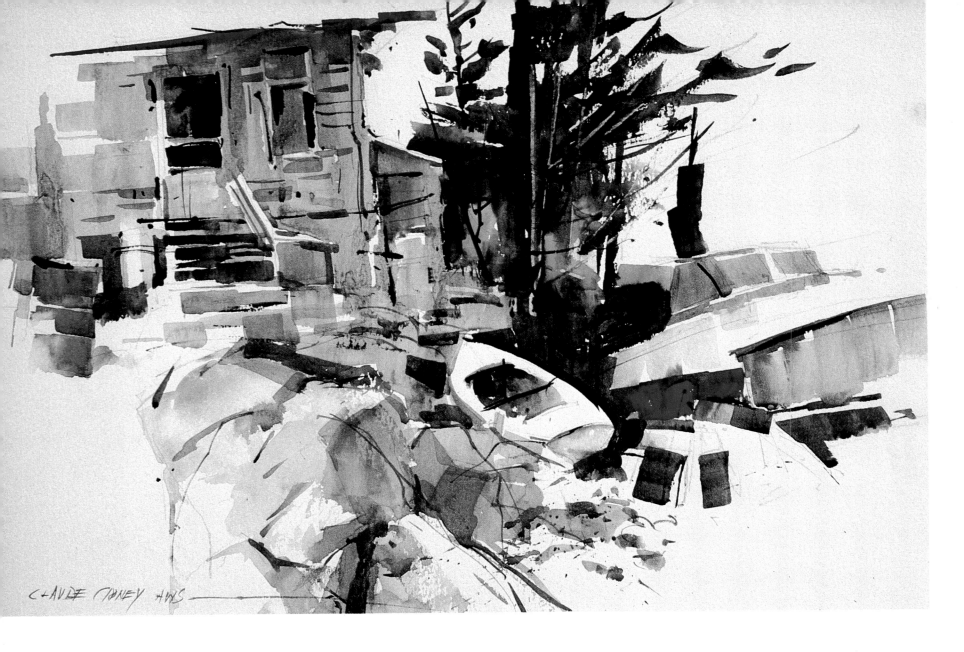

△ NELLIE GREEN'S SHACK (Connecticut)
*This is my favourite. It's such an allover
satisfactory painting. Claude has used the
bright orange next to the dark tree to attract the
eye first, which then travels down to the
counterchanged white dinghy at its base.
Although having much warmth, the shack and
foreground rock are kept subdued in tone.*

QUISSET HARBOUR (Cape Cod, ▷
Massachusetts)
*This whole painting displays a much softer more
subtle approach than any others I've chosen.
Whilst the background is very subdued, the steps
are strongly counterchanged with all the
dinghies and the two posts drawing attention to
them.*

64

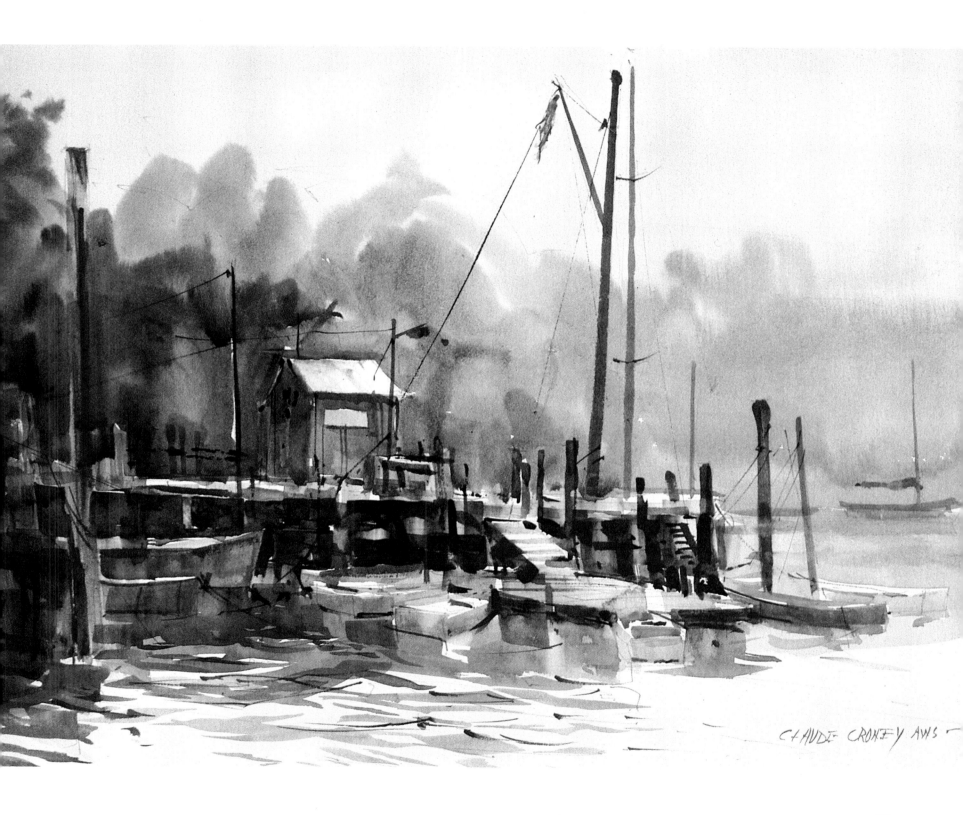

CLAUDE CRONEY AWS

65

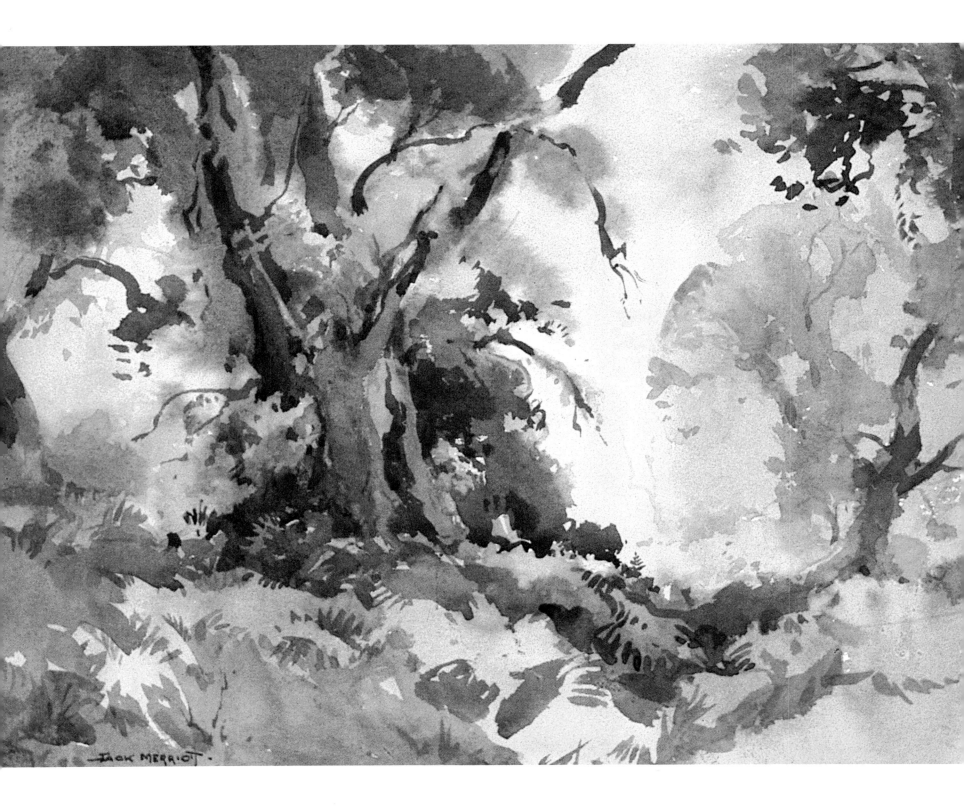

Jack Merriott VPRI ROI RSMA PS

Unfortunately Jack Merriott died before I even took up painting, so there was no chance to meet and work under him personally. However, on the various courses I attended, his name always seemed to be on everyone's lips and I very quickly became aware of the length and breadth of his influence. Not only was Jack Merriott a fine artist in pure watercolour tradition, he was also a

◁ MORNING ON THE COMMON
A really strong, clean, direct watercolour. The distance has obviously been painted wet-into-wet with cool blue green and after this has dried, the stronger richer greens have been painted progressively. The foreground undergrowth is particularly clever, painted in a range of warmer greens to bring it forward. The whole thing gives a lovely illusion of depth.

dedicated and enthusiastic teacher.

He infected everyone with his zeal and enthusiasm on his painting holidays and courses, so no wonder they were always booked up years ahead. He visited art societies throughout Britain and such was his reputation that these gatherings were always packed to capacity.

Apart from his teaching, his output was tremendous. As well as his work in galleries and private collections, reproductions of his paintings were everywhere. Companies such as Rolls-Royce, Cunard, the railway companies and what was then the GPO demanded his work for publicity purposes. He also illustrated a series of travel books published by Blackie called 'Beautiful Britain'.

He orginally trained at St Martins School of Art and at first earned his living as a shipping clerk, while painting in his spare time. During this time, however, several of his pictures were exhibited at the Royal Academy and at the age of twenty-eight he decided to concentrate full-time on painting. He became successful almost immediately and was soon designing posters for the railway companies and the GPO.

He was equally at home in all mediums and achieved such excellence that he was elected to the Royal Institute of Painters in Watercolours in 1940, the Pastel Society in 1951, the Royal Society of Marine Artists in 1955 and the Royal Institute of Painters in Oil Colour in 1959.

It is, however, as a traditional watercolourist that he is best remembered. He was a great purist and had no time for what he considered short-cut methods such as masking fluid, wax resists and pastes.

He regarded such artists as Constable, Turner and Cotman with absolute reverence and felt that landscape painting demanded a real knowledge and love of the countryside, and also the ability to draw. To this end he was never without a sketchbook and meticulously filled hundreds of these throughout his life, encouraging his pupils to do likewise.

Although he used various techniques with his watercolour, his favourite and most frequent approach was to work in an entirely free and loose way, intermingling tinted washes and covering the paper without any previous pencil outline being drawn. He felt that if this method was to be successful it needed immediate and easy access to a continuous supply of paint, and his palette was always well primed with moist colour from tubes to enable him to make quick mixtures, from the weakest wash to the strongest colour. He tried to use his brush in as economical a fashion as possible. The greater area of his pictures was painted in one wash and, at the most, two or three applications in some parts of it. This resulted in paintings that were clean, pure and spontaneous.

In 1953 Jack Merriott met another artist, Ernest Savage, and from then on the two became close friends and business partners. This partnership enabled him to extend his teaching activities even further, and for the next fifteen years they worked together throughout Britain and Western Europe. Their association only ended with Jack's untimely death in 1969.

Four years later, however, Ernest edited and produced a book, *Discovering Watercolour*, which was based on an earlier Pitman correspondence course. Ernest said that it was his opportunity of paying tribute to a great friend and a great painter.

Jack Merriott was an avid exponent of outdoor painting and most of his watercolours were completed on the spot. In recalling these painting holidays, Ernest Savage said that Jack would be up at dawn throwing himself excitedly into everything. There seemed to be never a time, weather condition or place that wasn't absolutely ideal for a painting! This attitude created such an impression on his hundreds of students that for the rest of their lives they remembered and talked about it.

SPRING ON THE DOWNS ▷
This painting was done in a controlled wash method, without any previous pencil or pen outline being drawn. He commenced by putting the main lines in with very watery ultramarine. His mental process for this method was first to create a nebulous atmosphere providing depth to the picture, then the main shapes, colour masses and form were considered, and finally just enough detail to incite interest.

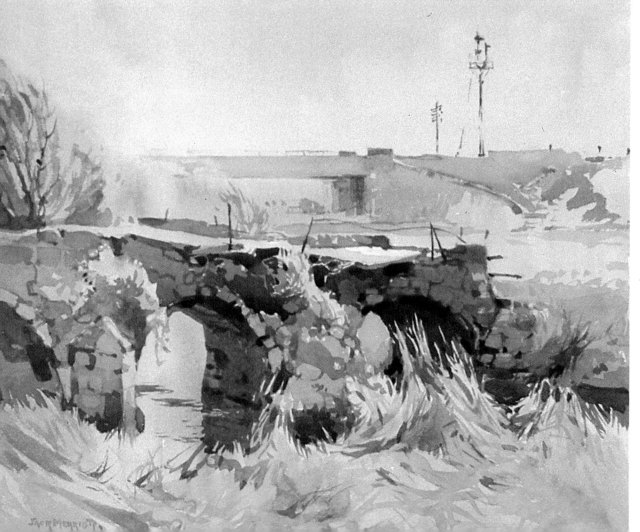

◁ THE OLD SHEEP BRIDGE, PULBOROUGH
This is a painting of two bridges, ancient and relatively modern, although I believe the railway bridge now no longer exists. Again, Jack used the old ploy of painting the distant one in cool, fairly flat colours and the foreground sheep bridge in rich, warm, contrasting colour with plenty of counterchange and texture. The foreground grass is beautifully handled too.

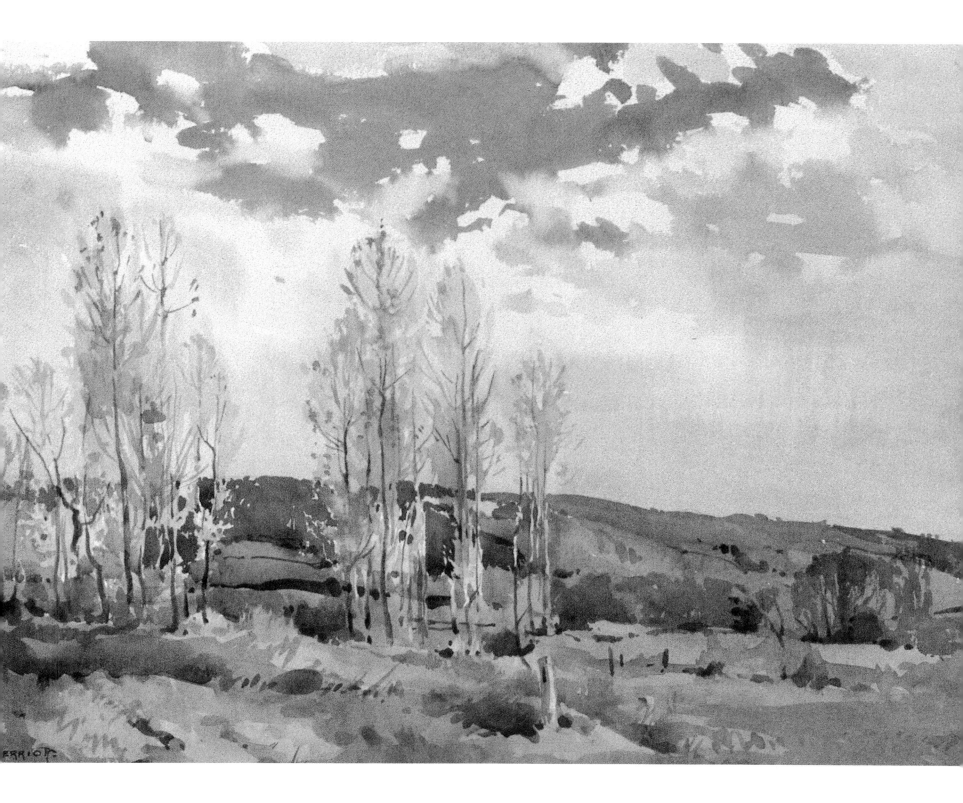

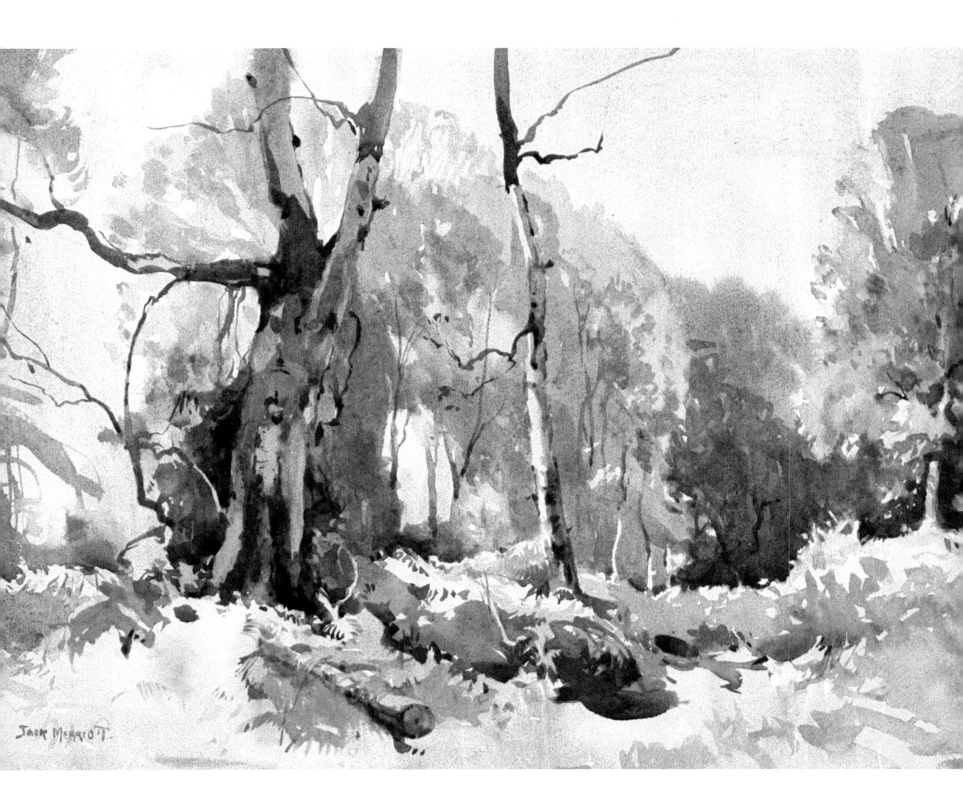

TREES ON THE COMMON

A beautifully balanced painting dominated by the large foreground tree on the left with the smaller adjacent silver birch carefully placed at a different angle. These are balanced up by the dark at the base of the left hand distant tree. The foreground texture in warm fawns and browns is economical yet very descriptive, with plenty of counterchange.

ST. PAUL'S CATHEDRAL AFTER THE ▷ BLITZ, 1942

Trevor Chamberlain, another artist in this book, showed me this picture when I went to visit him and suggested that Jack Merriott be included. He kindly lent me this painting to start me off. It's entirely different from all the others here but full of very subtle colour, sensitivity and texture. There is an incredible air of dust and devastation, with the foreground figures apparently searching the ruins for belongings.

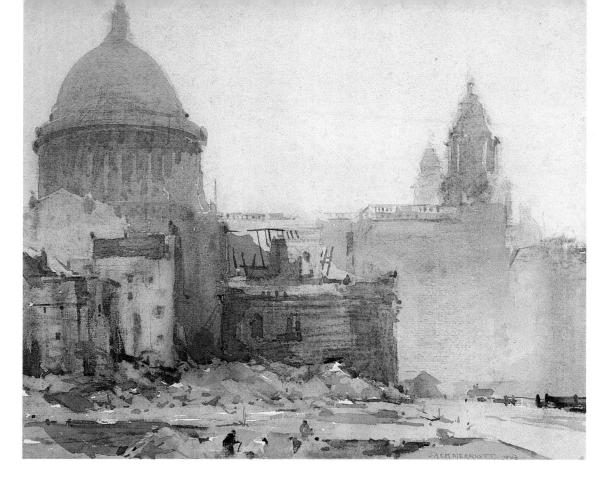

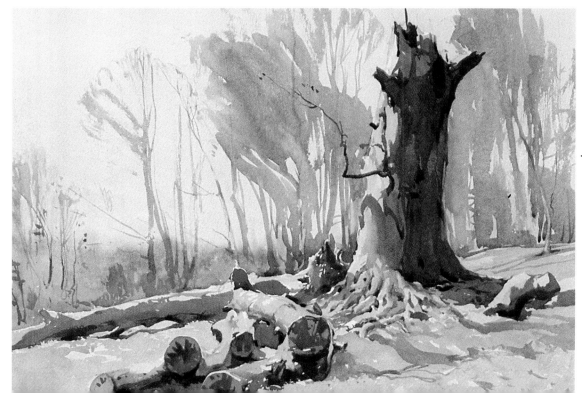

◁ STORM DAMAGE, ARUNDEL PARK

There are two entirely separate planes here. The row of misty grey trees in the distance with, to their left, some subtle and restrained colour. In front of all this is placed this strong 'L' shaped foreground design, full of contrasting light and shade. The ends of the logs, being the nearest, are the darkest and warmest colour of all – there's a lot to learn from these paintings!

71

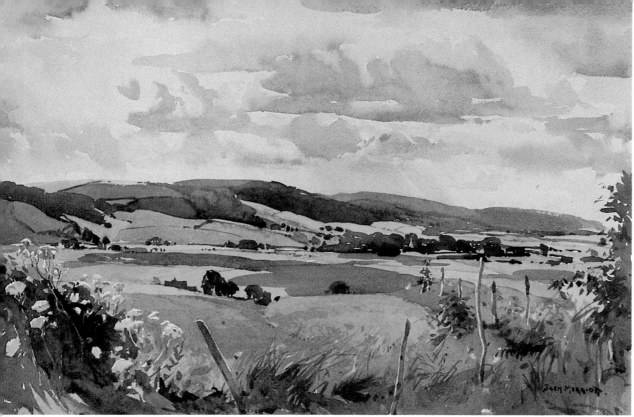

FARM TRACK TO GREATHAM ▷
This could be called a symphony of warm and cool colours which are interspersed all over the painting. The scene is dominated by the strong. dark foreground tree on the left with the rich browns at its base. Again from that point the colours and tones generally recede, and the curve of the lane holds the eye in the picture.

▽ TOWERING TREES AMID THE BRACKEN
Another strong 'L' shaped composition, the main centre of interest being the base of the dead tree on the left. One's attention is drawn to it because it's the area of greater counterchange and warmth. The further away one gets from it, the cooler and flatter becomes the colour and tone.

△ SHADOW TRACERY OVER ARUN VALLEY
This picture is full of interest. From the strong foreground hedgerow the eye is taken by the diminishing post to the scene proper with all its cloud shadows and patches of sunlit fields, and on into the cool grey hills in the far distance; overall are the scurrying clouds – all very satisfying.

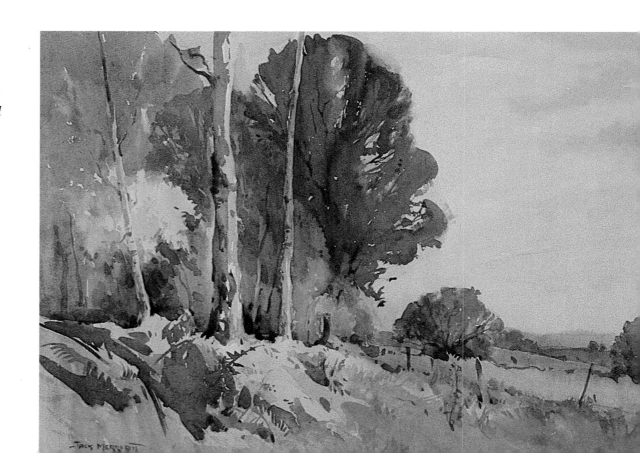

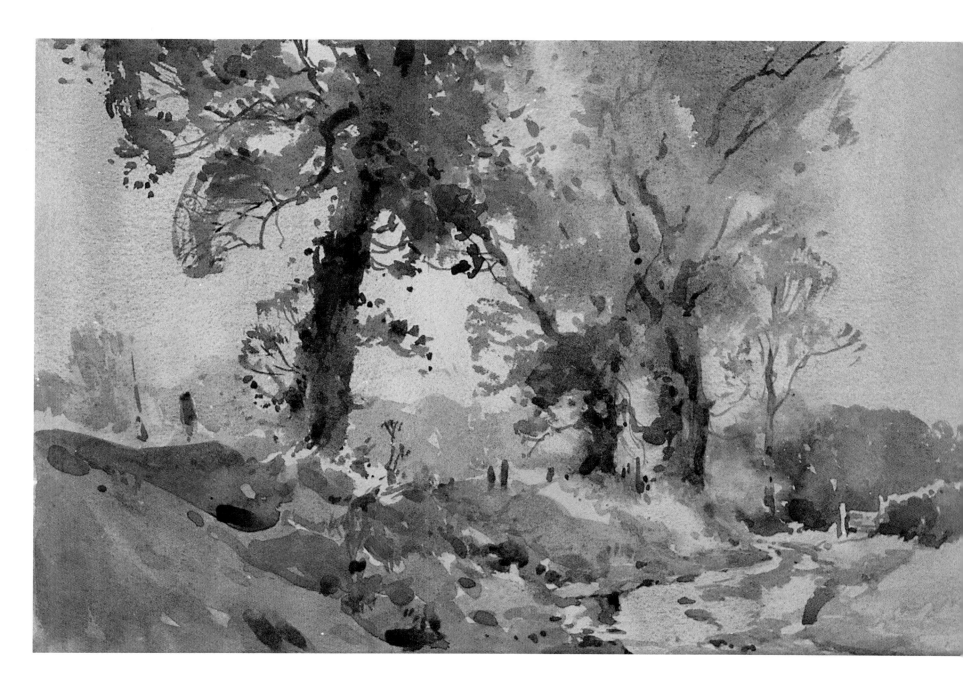

Tony Couch

I feel a great affinity with this chap. We both try to cram so much into our lives that we need a shoehorn. He's a watercolour artist and runs workshops all over the United States – he's written a best-selling book, articles in magazines and makes videos. He is an elected member of ten painting associations and has won more than fifty art awards. The amazing thing, though, is that he's also a pilot for Delta Airlines!

North Light, my distributors in the US, gave me a copy of his book, *Watercolour – You Can Do It!* and although I have literally hundreds of watercolour books at home, this one really made an impact on me. It is bursting with strong rich colour paintings and the copy is written with panache and enthusiasm. What's more, so much of what he says confirms what I've been trying to drum into my students for years. He believes that perspiration is far more important than inspiration. Would-be artists with moderate aptitude but with lots of determination and energy can, and often do, outpace more 'talented' students who put less effort into it.

He says practice and more practice is the key. 'While you practise keep in mind that watercolour painters are divided into two groups – those who have been discouraged and those who will be discouraged. There is nothing wrong with discouragement – it's part of the game – the crime lies in quitting because of it. If you have the desire you'll become a competent painter and the only way you can fail is to quit.'

Quoting from his ex teacher, Edgar A. Whitney, ANA, under whom he studied at the Pratt Institute in New York, he said that artists should be shape makers, symbol collectors and entertainers. You can see clearly from looking through the paintings collected here that he truly followed his teacher's advice. The shapes he makes are good, sound, interesting ones.

Regarding the symbols, Tony says watercolour is not the best medium for detail painting, it's only at its best when it's fresh and spontaneous. This means rendering the first fast impression of a subject without detail, and to achieve this you must do two things – simplify and symbolise. Symbolising means that we don't have to report objects in all their detail as a camera would, but rather invent symbols for them, so a translation job must be done. After all a painting is a lie – it's only paint and paper but we must convince viewers that they're looking at a landscape. Going further, an artist should be able to show beauty in subject matter that isn't readily available to the layman. Hence we lie, cheat and steal to effect this translation from reality to paper.

He says that viewers must be entertained by your paintings or they'll just pass you by, and entertainment in painting means lots of variation and change. To avoid boredom one must continually use variation in shape, colour, tonal value and texture to keep our viewers' attention.

I've rarely found an artist who so obviously sticks to his rules so dramatically – he really practises what he preaches, and to an artist an occasional glance through his paintings is like a shot of adrenalin. Whilst most of us, especially British artists, would not work in such a staccato fashion, his work is a constant reminder of something that we often forget – the principles of design in a painting. He lists various principles for building up a painting, some of which are self-evident and obvious, but a few need a bit more explanation. One of these is graduation, which means a gradual change from one thing to another, be it colour, from warm to cool, or tone, graduating from light to dark. He sees it as a technique to be used as often as possi-

SPRING PASSAGE ▷
The real contrast and focus of attention is in the middle of the painting here. The eye is drawn into the picture by the zigzag river, and stops at the fisherman in the distance. The soft dark of the trees makes a rich contrast with the distant mountains. Tony has also used graduation in the river from front to back.

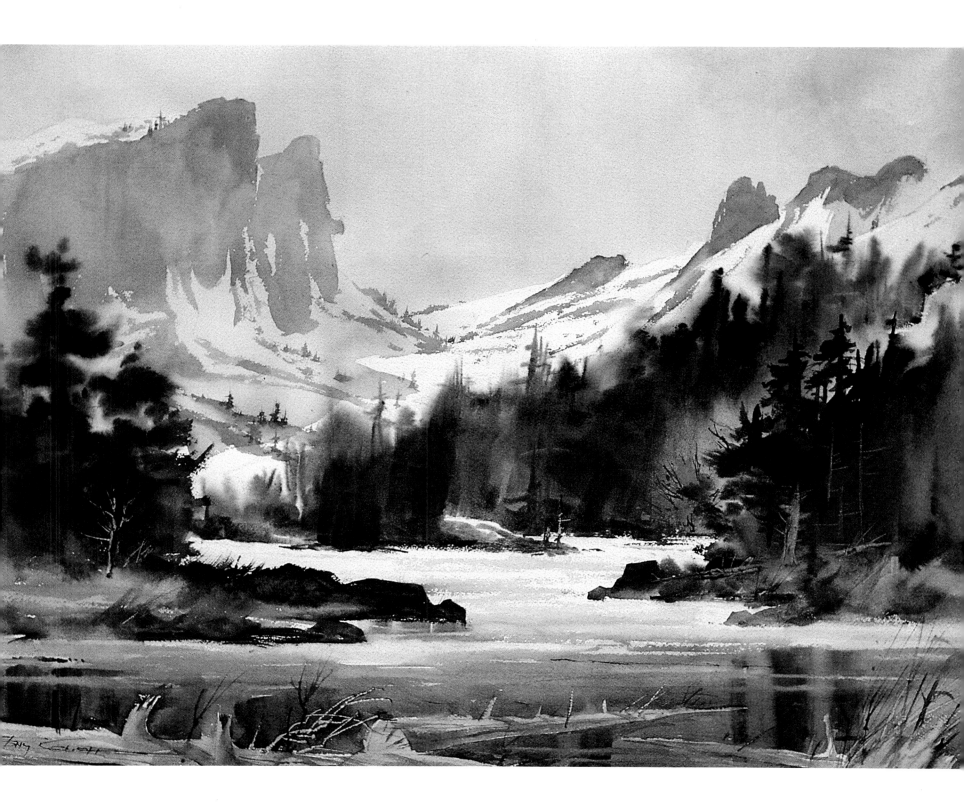

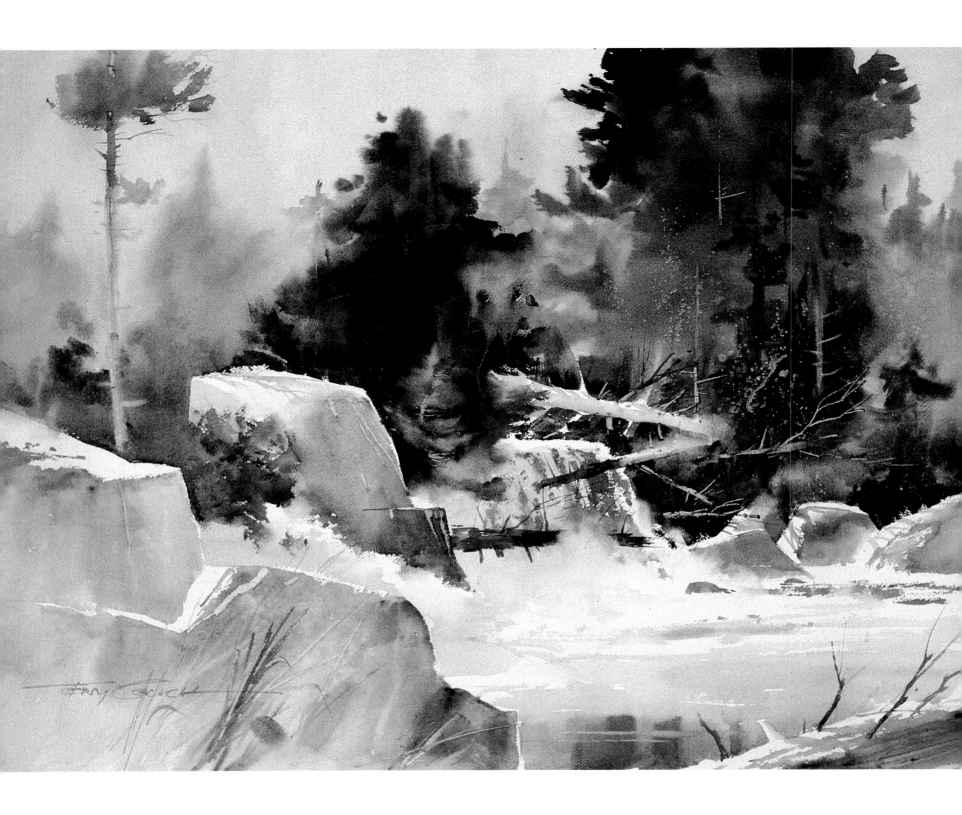

ble, transforming a flat, dull area into something more alive and interesting. You not only see it in his foregrounds and skies, but even in sides of buildings and tree trunks. This factor exists in nature but he automatically exaggerates to make it more interesting. He is a great believer in contrast – horizontal against vertical, rough versus smooth, soft versus hard, light against dark.

One of the most important principles is dominance. One element in the picture should always dominate everything else – a specific object of interest. This is done by making one object larger than all the rest, making it the area of greatest contrast, putting the brightest colour there, or by a combination of these techniques.

And finally, unity – any design must be a complete unit rather than a collection of several fragmented pieces and the elements should all relate to each other. In the captions of the pictures I have tried to point out where these principles have been used with great conviction.

Tony is also an ardent advocate of small preliminary sketches before painting a picture to establish the overall tonal values. He said he had been reading and hearing about values for years without understanding how to use them, when one day he discovered they were placed in a *pattern* – 'It was as if the sun had risen,' he said, 'my paintings improved 1,000 per cent. Placing these value ranges into a pattern organises your picture and creates order from chaos.'

I feel I have learnt a lot from this man – not because he told me something I didn't already know, but because he has made all the vague theory come alive and seem more practical and exciting. He's a very good communicator – after all, isn't that what being an artist is all about?

◁ NORTH WEST FORK
A very bold contrasting painting where strong counterchange has been used to maximum effect. The sharp edged boulders stand out dramatically against the soft dark of the woodland behind. You'll see graduation again in the way he's treated the foreground rocks, using very warm colours merging into cool, and cool into warm. The wet-into-wet treatment of the forest is also rich and exciting.

SUNDAY MORNING ▷
Look at the way the darks are used to throw up the profiles of the pier and the boat, and the graduation, in a subtle way, on the roof of the building and on the hull of the boat. There's plenty of interesting contrast and counterchange in the ladder, posts and mast.

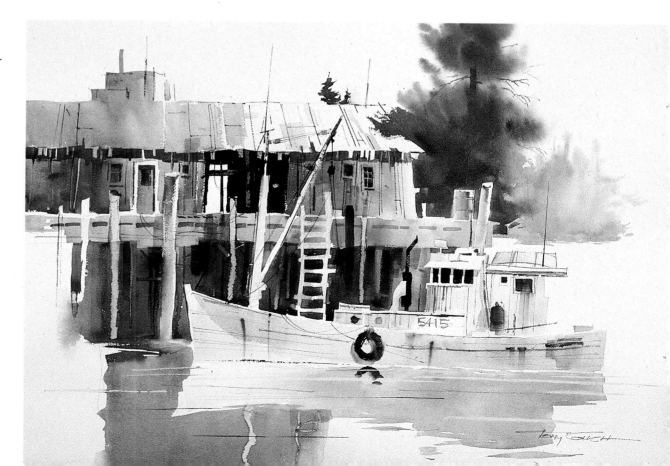

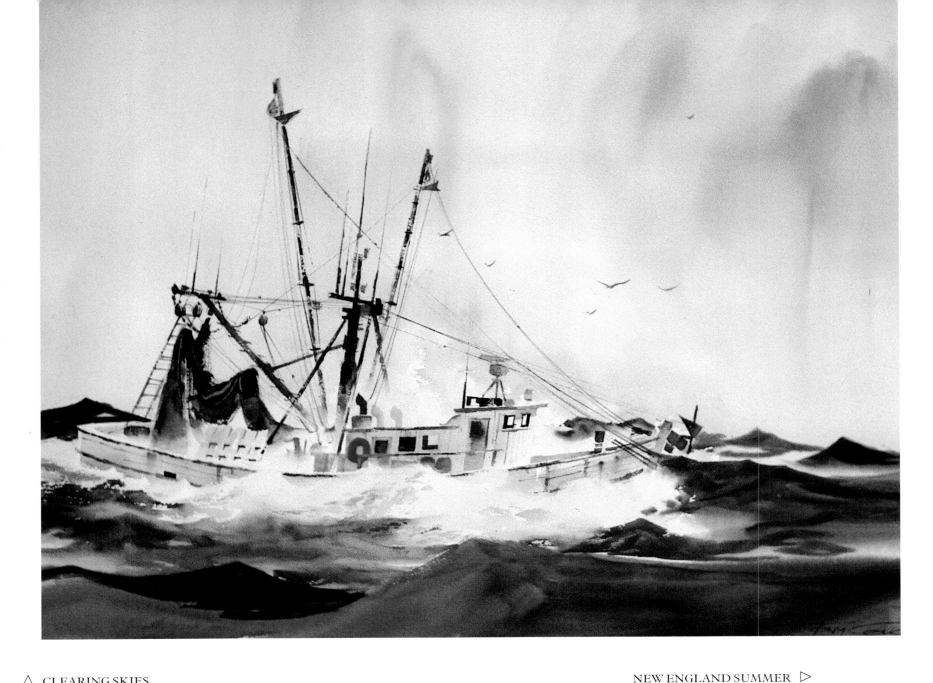

CLEARING SKIES

Notice how the rich swell of the ocean has been indicated to contrast with the spray around the boat. All the detail is confined to one small area of the picture with its tiny area of warm colour. The rest of the painting has been kept cool and spacious.

NEW ENGLAND SUMMER ▷

The eye is drawn immediately to the covered bridge by the use of detail and contrast. It is even more highlighted by the surrounding darks. The foreground rocks have been subdued in tone so as not to compete with the bridge. Again, some lovely wet-into-wet trees.

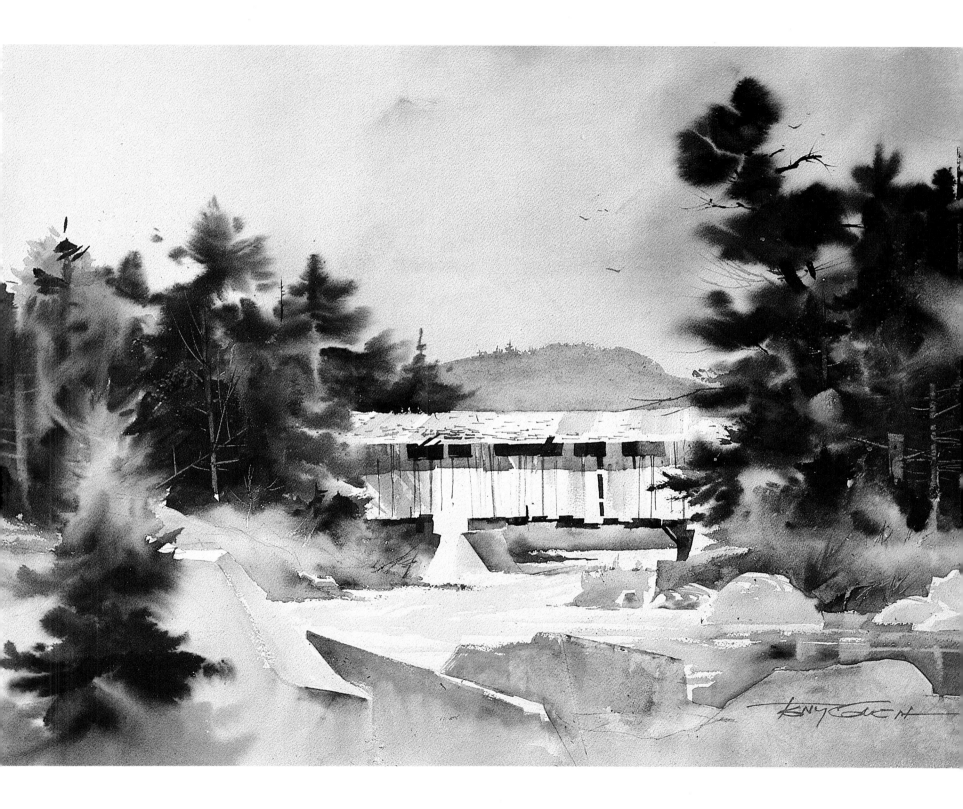

DAY'S END ▷
Tony Couch has used the dark trees on the left to
pick out the profile of the white barn, and notice
how he's used the tip of another tree on the right
to do the same on the roof. The main object of
interest is, of course, the horse, which is being
put away for the night, given maximum contrast
against the white barn. Note the graduation on
the foreground grass and even the shadow
underneath the roof.

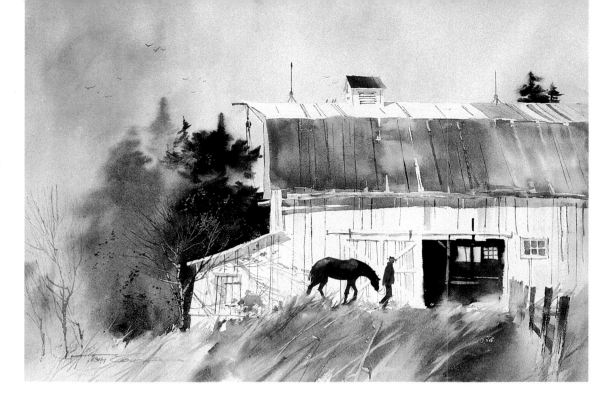

◁ WEST VIRGINIA ADDRESS
Like his other paintings there is a very satisfying
tonal pattern about this picture, the profile of the
roof being formed by the dark trees behind. I
love the wet-into-wet foreground grass with lots
of graduation and texture. Notice the nice little
touch of the mail box silhouetted against the
distant foliage.

PIT STOP ▷
This picture is all about a boat being beached for
repairs with all its detailed paraphernalia, but
look at the lovely foreground with all its soft,
cool and warm graduation and texture that
contrasts with the staccato counterchange shapes
behind it.

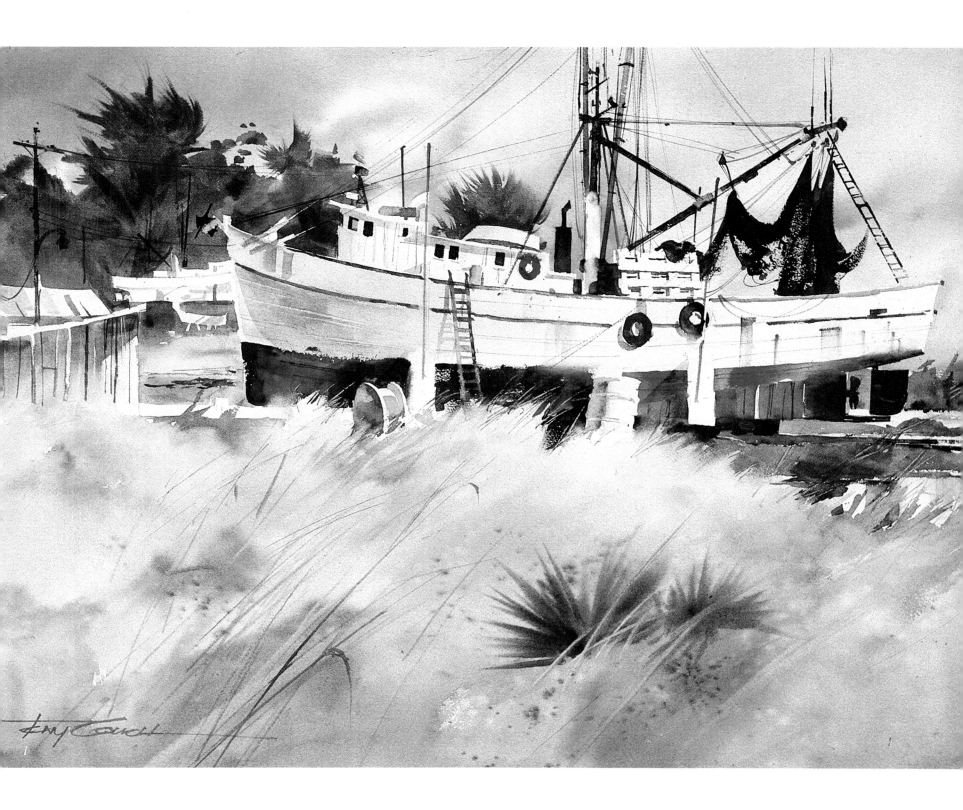

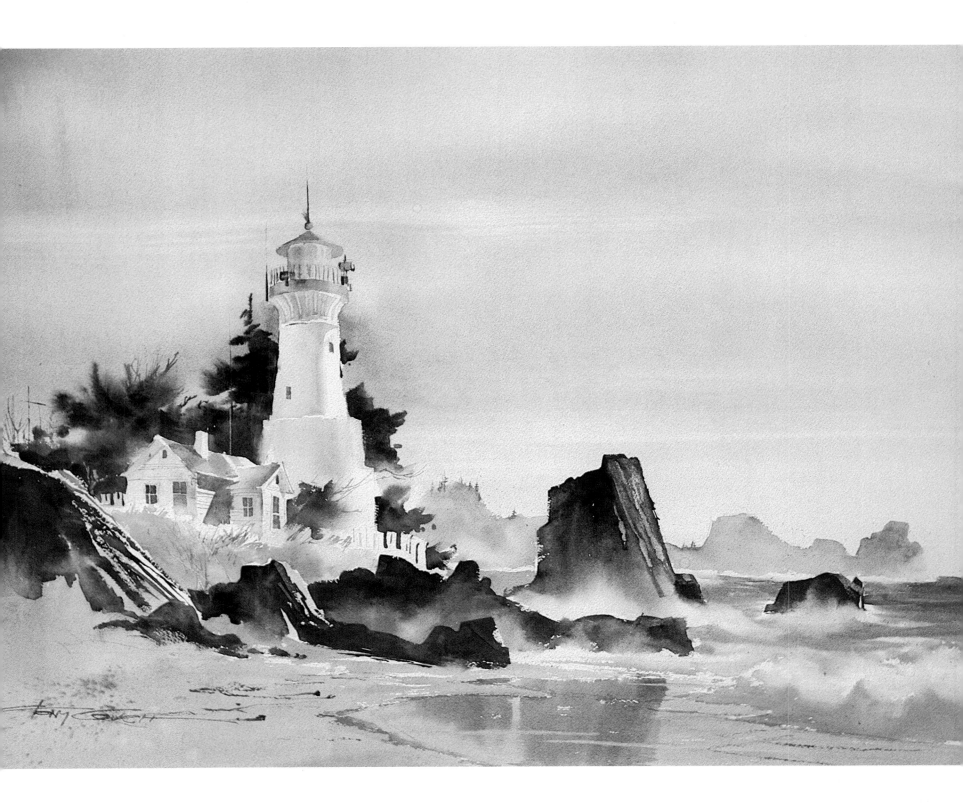

THE ROCKY NORTHWEST
There is continual counterchange around the lighthouse with the dark trees throwing up its profile and each of the rocks carefully contrasted one behind the other. The sea and the wet sand are handled beautifully.

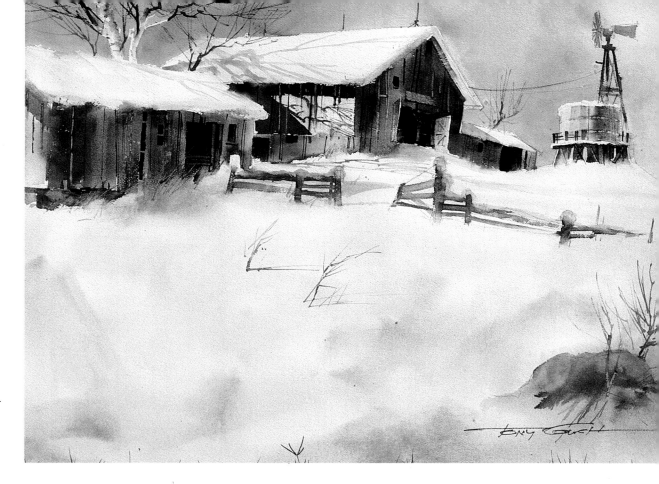

CRISP ▷
There's graduation in warm and cool colour in the barns and even in the foreground snow. I like the way the tree throws a shadow on the roof and is also reflected in the window. Notice how important the blue foreground rock is, to the balance of the picture – try covering it up.

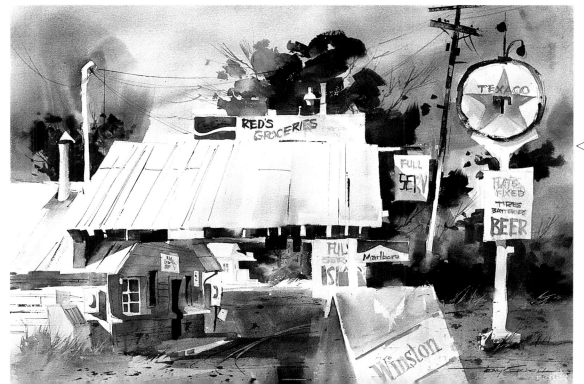

◁ RED'S GROCERIES
With so much pattern and abstraction about this painting, it might almost have been done by Frank Webb. The various white shapes are placed carefully on a dark background full of rich graduations of colour, both warm and cool. Notice, too, how the telegraph pole has been changed from white to black – again to provide exciting counterchange.

83

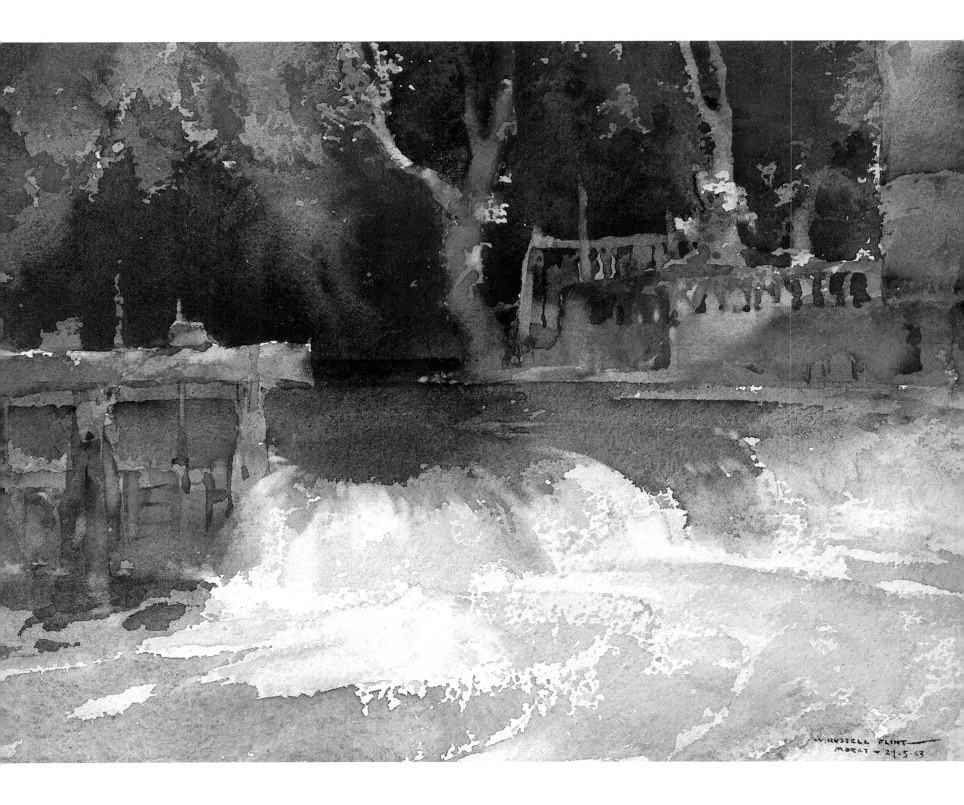

Sir William Russell Flint

RA PPRWS

You may be surprised to see this artist included in the book at all, but having long been an admirer of his work I felt that this was an excellent opportunity to share with you some of his wonderful, but perhaps lesser known, works painted in a freer style.

Whilst it was once said of him that no other artist had given so much pleasure to such a vast number of ordinary men and women, art critics and intelligentsia were constantly scornful of his olive-skinned gypsy girls and bare-to-the-waist maidens. The more popular he became, the more scathing became his critics. Perhaps it's as well

◁ THE WEIR AT MORET
The tremendous amount of movement in the swirling waters was achieved by the directional brush strokes. The drama of the painting is in the strong contrast between the rich dark greens and the white water as it tumbles over the weir – the structure of the lock gates is the connecting link between the two areas.

to remember that whilst art critics may be here today and gone tomorrow, Russell Flint's paintings will continue to become more and more sought after. None of his figure studies has been included, however, as I feel that these have been almost over-publicised.

Let's talk first about his artistic achievements, which are really awe-inspiring. At twenty years of age he went to London from Edinburgh and became a medical illustrator. Three years later he was appointed a staff artist at the *Illustrated London News* and seven years after that was elected to the Royal Institute of Oil Painters. In 1917, at the age of thirty-seven, he was made a member of the Royal Society of Painters in Watercolour and in 1924, an ARA. In 1933 he became a full Royal Academician. Three years later he was elected President of the Royal Society of Painters in Watercolour and remained in this office for over twenty years. In 1947 he was knighted and in 1962 he achieved the highest distinction that any artist can achieve in his own lifetime, when he was accorded a one-man exhibition at the Royal Academy.

Let's now look in some detail at some of his materials and techniques, but first let me quote from him – 'Amateurs are apt to believe that if only they knew the tricks they would be very good painters, but ten thousand tricks will never make an artist'.

He once said that his own methods were extremely simple, as were his materials – which consisted of an ample supply of clean water, a few pure permanent colours, large

sable brushes and the whitest, heaviest (300 pounds), and sometimes roughest, paper, a very large hogs-hair brush for 'scrubbing', several flat hogs-hair brushes for 'lifting off' and one or two tiny sables for the odd detail.

While his large landscapes were painted on location, his figures were added later in his studio where he always worked from models. There he would remove the background where the figures were to be, with a small flat hogs-hair brush. With this he could get back to white paper where necessary – a technique that required much time and patience.

He felt he had no technical dodges and believed that these were valueless. His chief objective, he said, was to get the desired effect with as little appearance of labour as possible. Isn't this something that most of us strive and work towards all our lives?

The thick 300-pound paper he used was, I believe, a very important factor in his work. It meant that he could alter his washes when dry, lifting out such things as foliage with blotting paper, and even burnishing the grain of the paper in parts, whilst soaking it, in others, to achieve a misty effect. The important thing was that Russell Flint knew exactly what would happen when paint, water and paper came together. In other words, he was always in control of his materials.

His palette was surprisingly simple. Cobalt blue, ultramarine, cerulean, light red, yellow ochre, Indian yellow, burnt sienna and rose madder were his main colours and only occasionally did he supple-

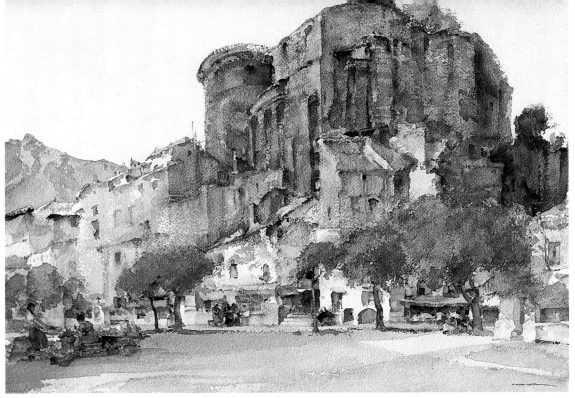

◁ LA VOULTE-SUR-RHÔNE
One of the many admirable things about Russell Flint's painting is his masterly portrayal of old stone in his buildings, whether interior or exterior – I know of no one who can do it better in watercolour. Here the detail in the château is absolutely minimal, yet the impression is one of complete authenticity – any detail work is confined to the busy street scene below.

▽ ECLUSE ON THE LOIRE
This is a very calm, sunlit painting with a great sense of space and distance. The position of the single foreground figure is important and contributes to the general air of peace and tranquillity.

ment these with other shades.

What I've tried to set out for you here is, that although Russell Flint was best known as a painter of beautiful girls – the print publishers undoubtedly concentrated on this – the other side of the coin was that he was a serious and sensitive artist who painted very many more landscapes than figures. I hope that the pictures shown here will demonstrate his genius as a landscape painter in the Impressionist manner.

To close this chapter, let me quote a President of the Royal Academy, Sir Charles Wheeler, who said of Sir William: 'Broadly speaking an artist's business is to communicate his thoughts, ideas, and emotions to those of his fellow men who are willing and able to receive them. Judging by their wide acceptance it can be said with certainty that William Russell Flint has served his generation well. No more is expected of any man. Posterity will see to the rest.'

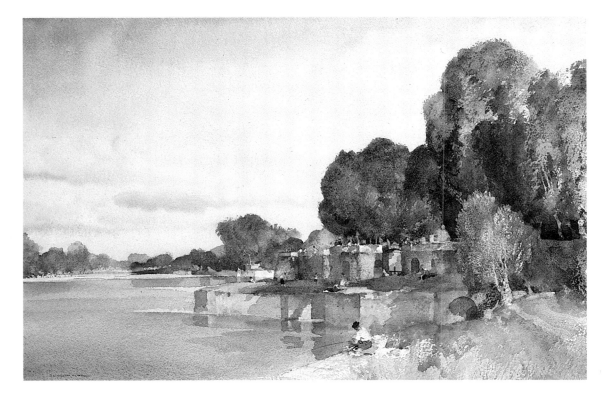

▽ THE PUY DE DÔME
The richness and strength of this picture is masterly. Russell Flint has achieved much of this by fiercely and deliberately counterchanging such things as the dark mountains against the small area of blue sky; the rich warm browns of the foreground are contrasted against the cooler greys in the distance. The darks in the bottom righthand corner are balanced up by the dark clouds in the top left.

87

◁ CASTILLON DU GARD
Russell Flint has managed to convey a wealth of information in the foreground using an absolute minimum of strokes of warm colour. The eye is taken down through the gorge, deflected by the dark group of trees into the cooler grey green distance and on to the building on the skyline. This itself provides a tiny area of warmth against the cool sky.

△ ON A BRETON BEACH
There's a lovely colour scheme throughout this picture – it fairly sings with light. All contrast and activity is confined to one small area, the rest of the painting being left clear to provide a dramatic sense of space.

89

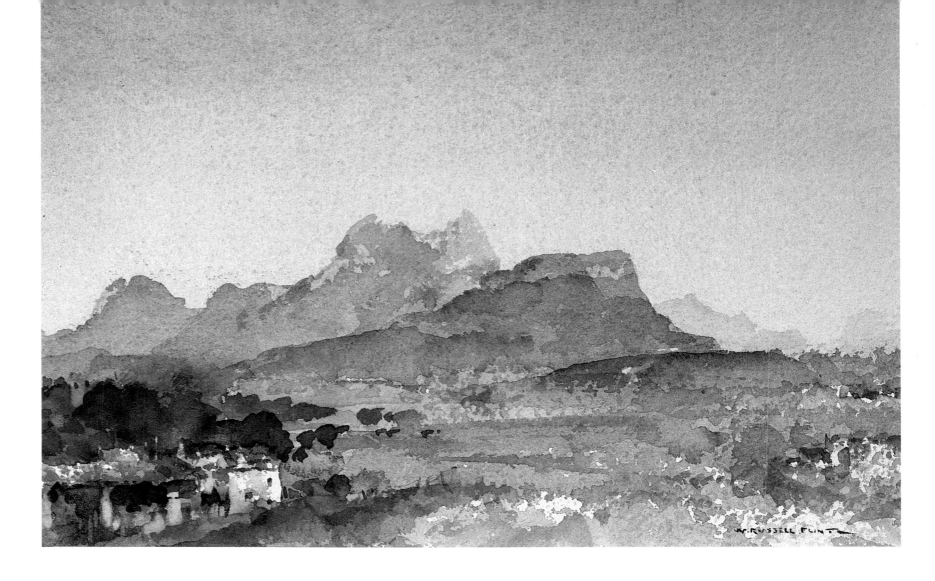

△ LA ROCHE COLOMBE
This is a far gentler mountain scene than the one on page 87. No dramatics here, just a subtle progression of soft colour. All the contrast and strength is confined to the left foreground, giving depth to the whole painting.

PAPADOPOLI BRIDGE, VENICE ▷
This is a very much looser and more Impressionistic painting than most of his Venetian scenes, as it's done on a very much smaller scale (only 7½in x 10¾in). He seems to convey a lot of apparent detail but on closer inspection one finds that everything – windows, figures, boats – is merely hinted at, allowing us to use our own imagination – which is surely the aim of Impressionism.
(Courtesy of Richard Green)

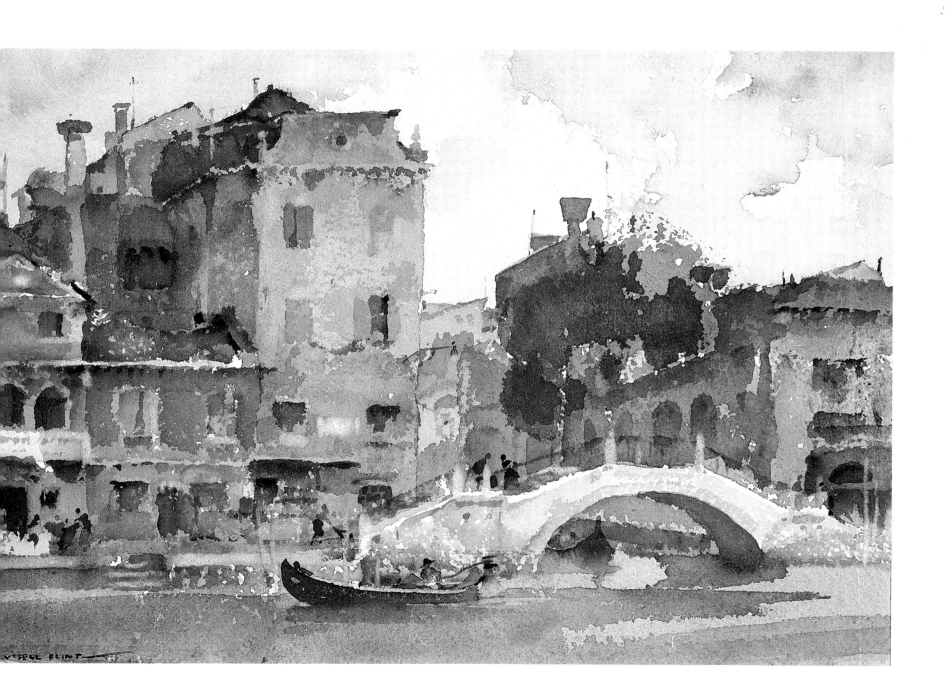

Edward Wesson *RI RBI RSMA*

Edward Wesson was a character with a capital 'C'. He will be loved and remembered by the multitudes of faithful followers who filled every course he ran for year after year. His work and approach exerted an enormous influence over thousands of amateur painters. The tremendous demands on his time and energies affected his health and may have contributed to his untimely death in 1983 which left a sad gap in the art world.

I had a week's course with him at Walberswick a few years ago and enjoyed every minute of it. He had a very gruff, humorous manner and he would demonstrate with deceptive nonchalance – 'deceptive' because he seemed to do a painting with such ease and apparent lack of effort. The results he achieved were, however, the result of years of patient observation and practice.

His famous brush was a large, round floppy thing called a polisher's mop – really, I suppose, made for French polishers and never intended for the use of artists – but in his hands it produced free, fresh, uncluttered watercolours. One could not possibly fiddle and overwork a painting with such a crude brush – that was the theory anyway!

Everyone has a favourite anecdote about Edward Wesson. An earnest student asked 'What should I do if I had rushing water coming towards me?' Ted grunted, 'I should b…. off somewhere else as quick as I could if I were you!'

Edward Wesson was self-taught, as were so many other artists. Although he started painting early in life it wasn't until middle age he felt he could give up his business and concentrate on being a full-time professional artist. Having made the decision he found he doubled his income the first year!

In 1982 he published a beautifully illustrated autobiography called *My Corner of the Field* and in it said of himself: 'I believe I'm

BEACH SCENE ▷
There's a riot of very subtle, warm colour in this painting, especially on the left. I love that strong, spontaneous, but transparent, shadow across the foreground beach – obviously put in with one sweep of his arm. There's lots of strong counterchange, too, in the rocks with some of the paper left untouched. Finally, look at the way he nonchalantly indicates the children and their reflections.

▽ DEVON BRIDGE
A strong feeling of contrast here, with the sunlit bridge and cool shadows. There's a great economy of texture, both in the rocks and the structure of the bridge – not a stroke is wasted.

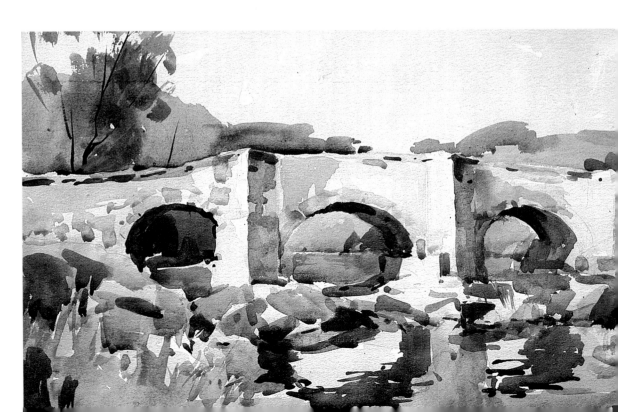

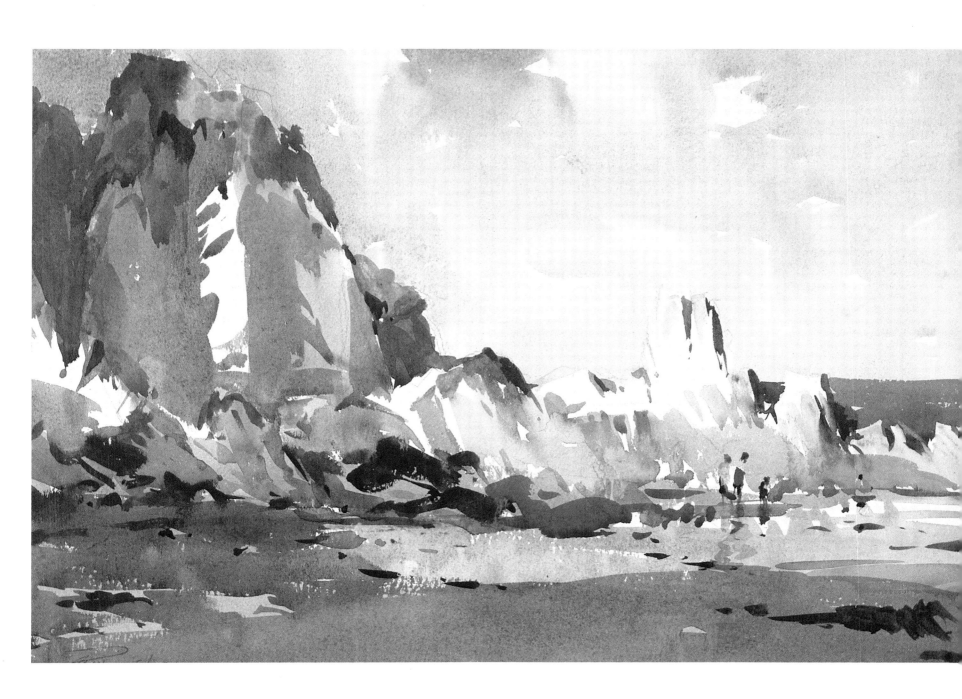

blessed with a clowning mentality which has enabled me to make a kind of Music Hall act of it all, which hopefully has amused more people than it has offended.' He also said that he felt that watercolour didn't bear being pushed around and worked on without losing its main quality. 'We need to simplify the subject in front of us so that there's no need of overworking or fiddling. We must make good use of the paper itself and try to lay all our washes on it only once which makes for luminosity.' He felt a good watercolour was a happy marriage between paper and colour. It is when we have to tinker about with it afterwards, adding a bit here and a bit there, that the process gradually obliterates the loveliness of the paper – then we know we've failed.

He was a real purist and was a bit scornful of some modern watercolourists who threw salt at their work or used body colour and scraping-out techniques. He said he preferred to let the other chaps play around with their excellent cameras, masking fluid, wax and bill-posters' buckets as long as he was allowed to continue in his corner of the field to look at the wonders of things around him.

At the end of his book he suggests that we need less in the way of mechanical aids and gimmicks in our work and far more fresh air. This philosophy speaks for itself in his work.

Whilst researching this book I went to see his wife, Dickie Wesson, who greeted me with her usual courtesy and good humour. I had met her some years ago when I attended Ted's course. She had the projector all ready and we went through two carousels full of transparencies of Ted's work. It was a great thrill to see them and I selected several for the book. When I got home, however, I found a lot of them had little splashes on them and was at first mystified as to where they had come from. Then, of course, I realised that these carousels had been taken to countless art societies on Ted's travels and they had become splashed with paint over the years. This is to explain any possible mysterious spots you may see on the illustrations, but also typifies his devil-may-care way of life – probably one reason why he was loved and respected by so many people.

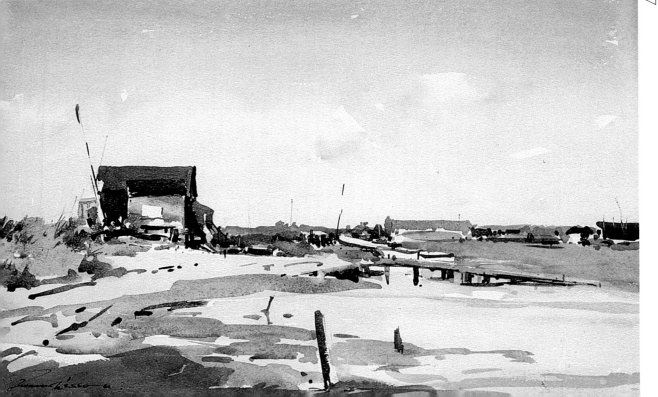

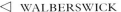

◁ WALBERSWICK
I once spent a week as a student of Ted's here in Walberswick – it was a superb place for painting, with lots of huts, boats and jetties. He has captured the whole feeling of the place with a clarity and spontaneity which his students struggled to emulate.

ROSES ▷
This painting is from Ted's autobiography. In it, he says 'I love open, fully blown flowers, which have a freedom about the shape and quality of light they seem to acquire just before they fade forever'. The table and drapes are very simple and the vase is an old jam jar, providing no distraction and allowing one to focus on the beautiful blooms.
(Courtesy of Alexander Gallery)

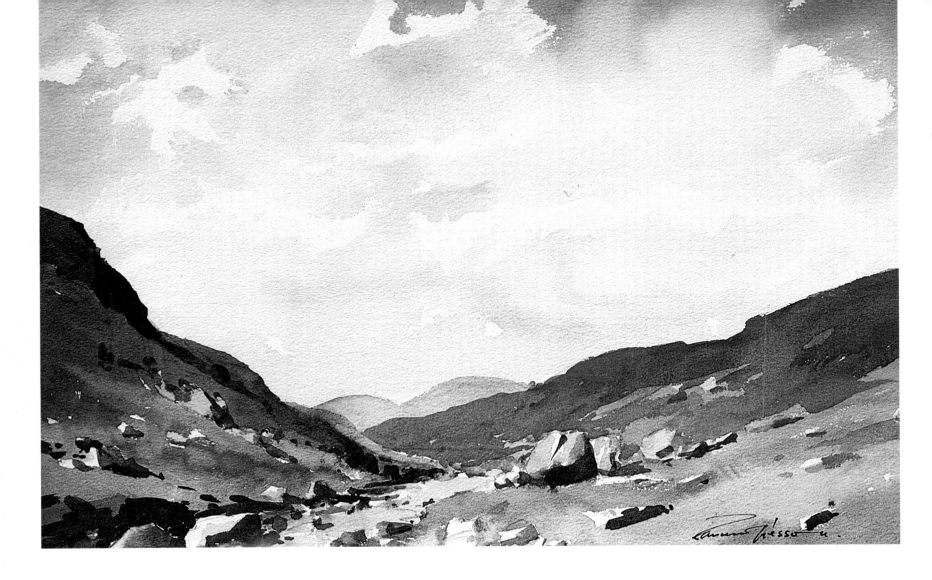

△ NORTH WALES
A painting of contrast and counterchange. The vigorous fresh sky complements the hard, dark, shadowed hills which, in turn, enhance the sunlit foreground. The rocks are given great strength and stability.

ICHENOR, NEAR CHICHESTER ▷
This is a really loose painting. Ted has captured the wet mud with immense vigour and dash. The main object of interest is the dark blue yacht, which is placed to form a direct contrast with the patch of light water above. Overall, a very exciting picture.

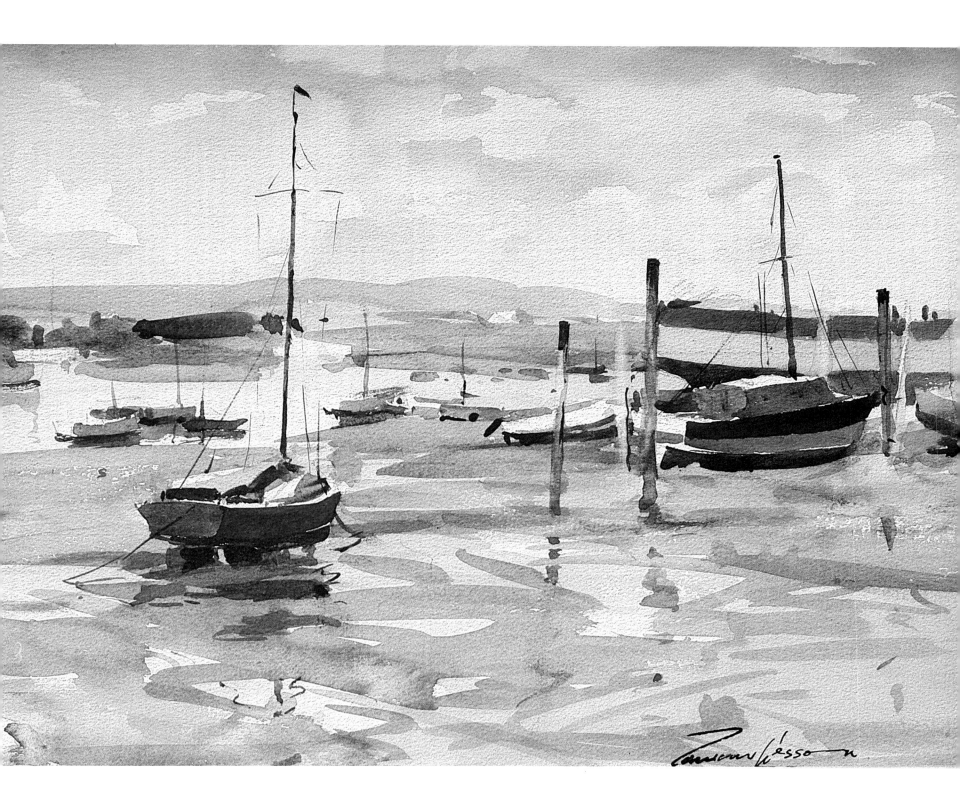

BLYTHBOROUGH CHURCH, SUFFOLK ▷
This painting is so full of atmospheric light and air it could almost have been done by Turner. There are beautiful wet-into-wet passages which contrast with the sharp silhouette of the church. It's strongly anchored by the dark line of trees.

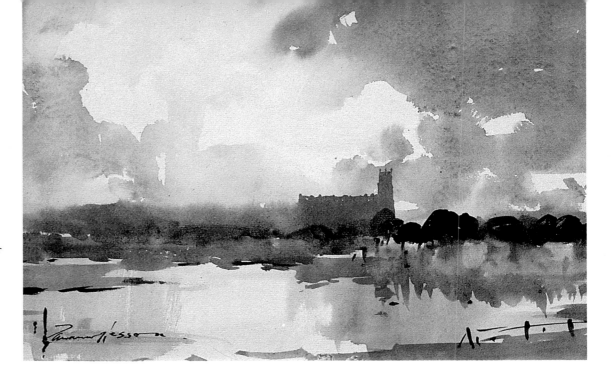

◁ SEA PALLING/WAXHAM
Another strong vigorous painting of two Norfolk village churches seen from the sand-dunes. The near village is handled with great economy and sureness, whilst the distant church is merely hinted at in silhouette. Look at the strong treatment of the foreground sand-dunes with their attendant shadows.

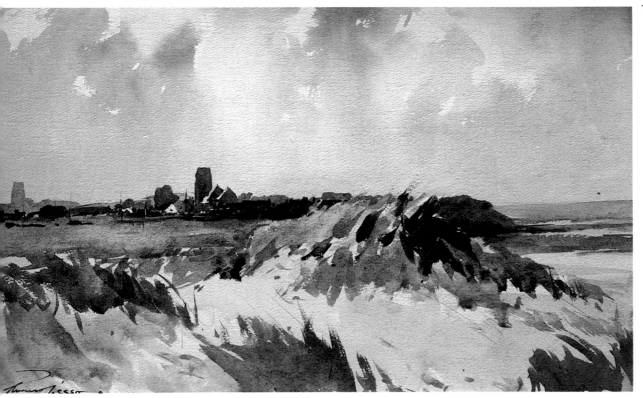

BROWNSEA ISLAND ▷
An enormous panorama is always a daunting thing to tackle in watercolour, but Ted has handled it with great confidence and attack, constantly counterchanging one layer against the next into the distance. Brownsea Island, in Poole Harbour, is famous for being the site of the first Scout Camp set up by Baden Powell.

△ SHERE, SURREY
Ted Wesson always had a way with trees and
this picture is a good example of his economical
treatment. It is also an object lesson in using a
warm, rich foreground against a cool
background, giving an enormous sense of depth.
Another trick is the way he changed the angles of
his trees to avoid monotony.

BEN LOYAL ▷
This is Ted Wesson at his best. With enormous economy of stroke and sureness of touch he created a beautiful painting of the Scottish Highlands. Whilst the foreground rocks and shore are in warm colours to bring them forward, the distant mountains are in cool colours and partly wet-into-wet to suggest rain.

◁ ST AUBINS BAY, JERSEY
There is a breath of sea air in the lively painting of this sunlit bay at low tide. The distant boats are beautifully indicated against the harbour wall. Also interesting, is the way the wet sand, with its sky-reflecting pools, is handled.

101

Don Stone ANA AWS

As I was wandering along a lonely track on the tiny island of Monhegan off the Maine Coast (there are no roads there), I was somewhat startled to hear someone call. 'Hi, are you Ron Ranson?' He introduced himself as Don Stone and invited me back to his studio to sign his copy of my book, *Edward Seago*. Whilst we were standing chatting who should come along but Jamie Wyeth, a world-famous artist in his own right and son of Andrew Wyeth, who has probably had more influence on modern American painting than anyone else. It transpired that James, too, had a house and studio on this magical island.

This was turning out to be a truly memorable day, and back at Don's studio it got even better – the paintings that hung everywhere completely bowled me over. They were superb and seemed to be in so many different styles and media – from tiny loose watercolours, to oils and large, detailed egg tempera paintings.

I felt like a child in a toyshop and was soon down on my knees in a corner thumbing through stacks of unframed paintings. Then there were the bulging sketchbooks – full of free Impressionistic watercolours on ordinary sketching paper, but each one vibrant with promise.

These loose sketches were, in reality, studies for Don Stone's large paintings in various media, but each tiny watercolour would stand on its own as a work of art. These had to appear in my next book. Don says that, although he himself refers to them as studies, they are no less significant; in fact just the opposite – 'After all these are my first impressions and sometimes, if not most times, better than the larger efforts.'

Incidentally, while most of the other paintings in this volume have had, of necessity, to be reduced, most of Don's have been reproduced full size and, in some cases, even enlarged. This hasn't detracted from them in any way, but you may wonder at the apparent size of his signature.

Don's work, overall, has received national acclaim. He is an Associate Member of the National Academy of Design, a Full Member of the American Watercolour Society as well as being elected to many other influential associations and guilds. He has now won more than sixty-five major awards, including eight gold medals, and his paintings have been bought for museums and private collections all over the world.

Few modern artists can have so success-fully mastered so many different mediums, each one presenting a fresh approach. The visual immediacy of his watercolours is translated with great skill and vitality into his larger egg tempera acrylics and oil paintings.

Don has an enormous respect for the American tradition of Realism and this is, perhaps, the unifying factor throughout all his various paintings, especially in his rural New England landscapes.

I've told you how my visit started. Now I must tell you how it ended. Don's other pride and joy is his collection of traditional American banjos, and the jewel of his collection was one he had specially commissioned. It has been painstakingly handbuilt over a long period of time, inset with exquisite mother-of-pearl. It was a thing of great beauty and, as I sat on the floor listening to his recital, I took the photograph of him that you see at the beginning of this chapter.

MIDWINTER ▷
This small painting (4in x 5in) has a really strong design element to it. The axe set in the block is the king-pin, counterchanged to the maximum against the background tree behind. You'll also notice that all the wood blocks direct the eye straight to the head of the axe. Even the streak of ochre in the foreground leads us to the main object. The house in the background has been deliberately subdued.

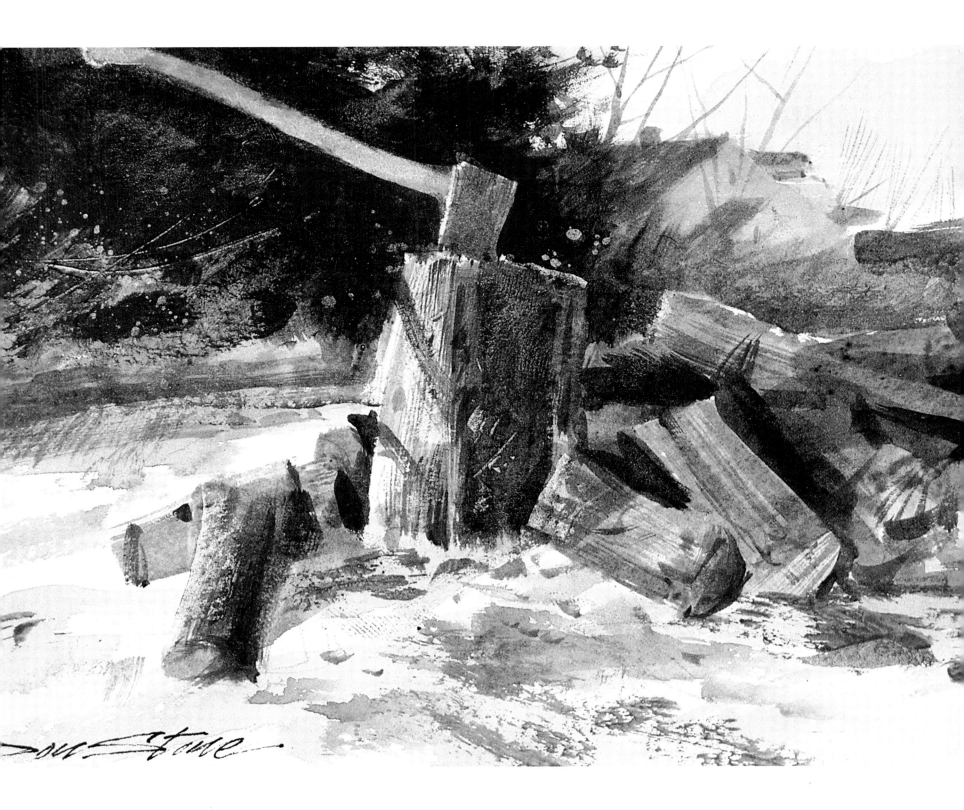

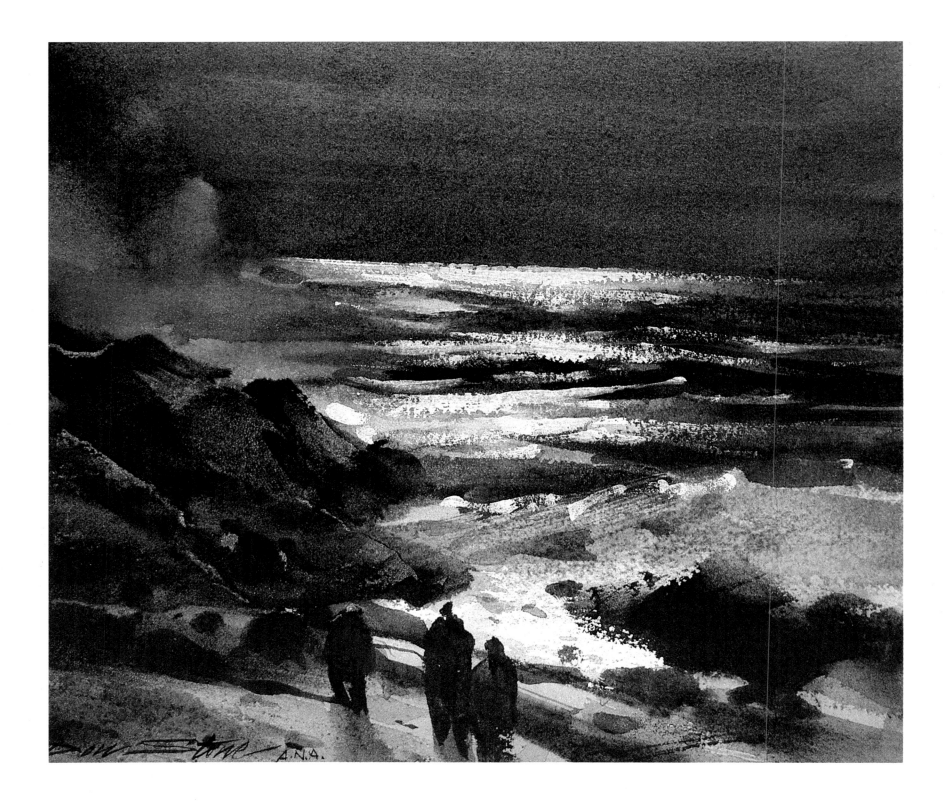

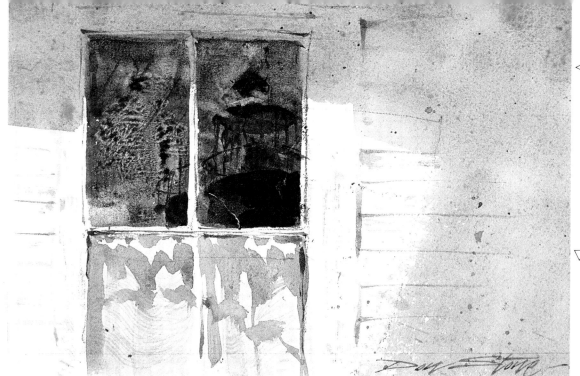

◁ REFLECTIONS
'Sometimes,' Don said, 'I know with just one study that I've got what I want' – this was true of this picture of Monhegan lighthouse reflected in the window. The intriguing point of the picture is that it isn't immediately obvious that the reflection is of a lighthouse – a very subtle and thoughtful painting.

▽ DWIGHT FISHHOUSE
This strong rich interior is beautifully lit. The subdued lighting is contrasted against the dazzling patch of sunlight on the floor. The hanging objects are, I believe, lobster floats – each fisherman has his own colour scheme in order to identify his traps. Notice the flowing blues and reds of the seated figures in the corner.

◁ FISHERMEN'S MOON
Originally 4in x 5in, this painting was done quite differently from the others – it was painted from memory with notations after returning from the scene. It is tremendously dramatic, completely conveying the atmosphere and effect of the moonlight on the water. A truly Impressionistic painting that later formed the basis for oil paintings.

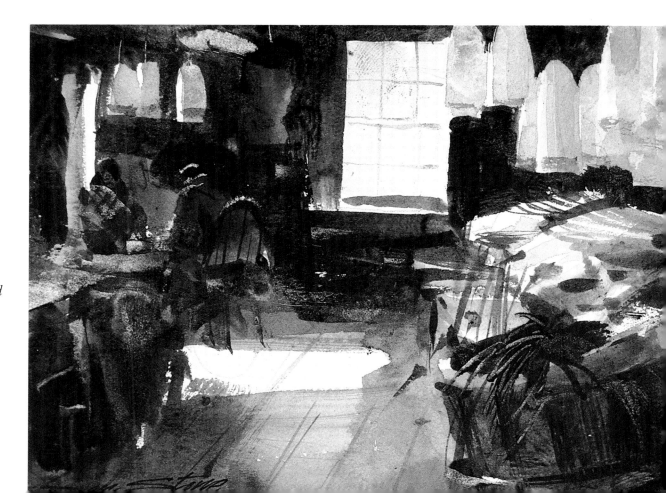

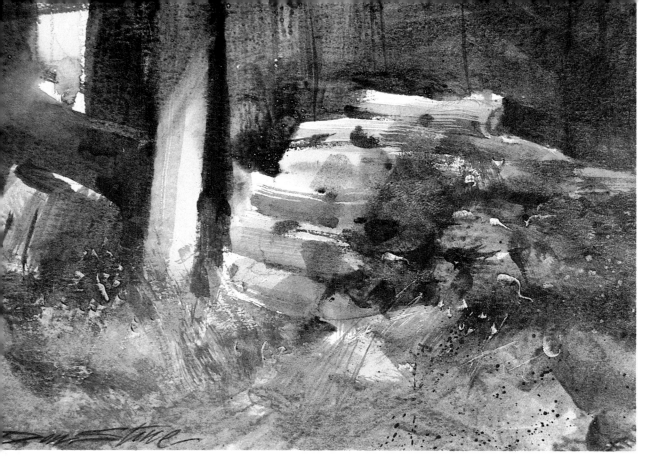

NORTH BERWICK ▷
This is yet another painting enlarged from a 4in x 5in original. It has a tremendously strong underlying pattern. Much of the appeal lies in the warm shadows across the centre of the painting. Note the way the light bounces off the snow onto the walls of the left-hand building. Notice also how the profiles of the roofs are picked out by the trees behind.

△ WOODPILE
This is a deceptively simple but very satisfying design. The eye is taken directly to the base of the vertical post because, while the majority of the picture is in dark, all the main lights are grouped round this area. The foreground texture is very economically indicated, showing the occasional use of spatter work.

HAULING BACK ▷
One of the exciting aspects of this painting is the strong feeling of movement as the fishermen haul their catch aboard. It's a beautifully balanced painting, emphasis being added by all the contrasting angles. Don ultimately did a large watercolour of this, which is now in the permanent collection of the Peabody Marine Museum in Salem, USA.

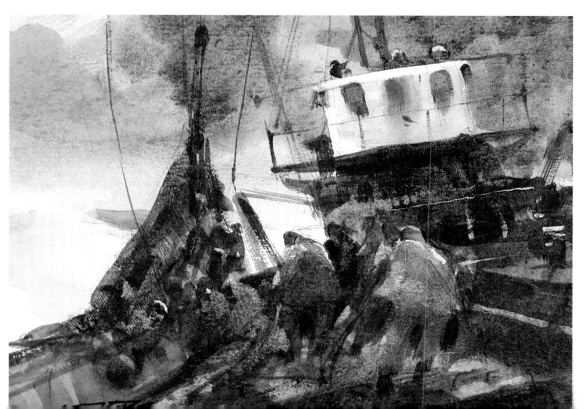

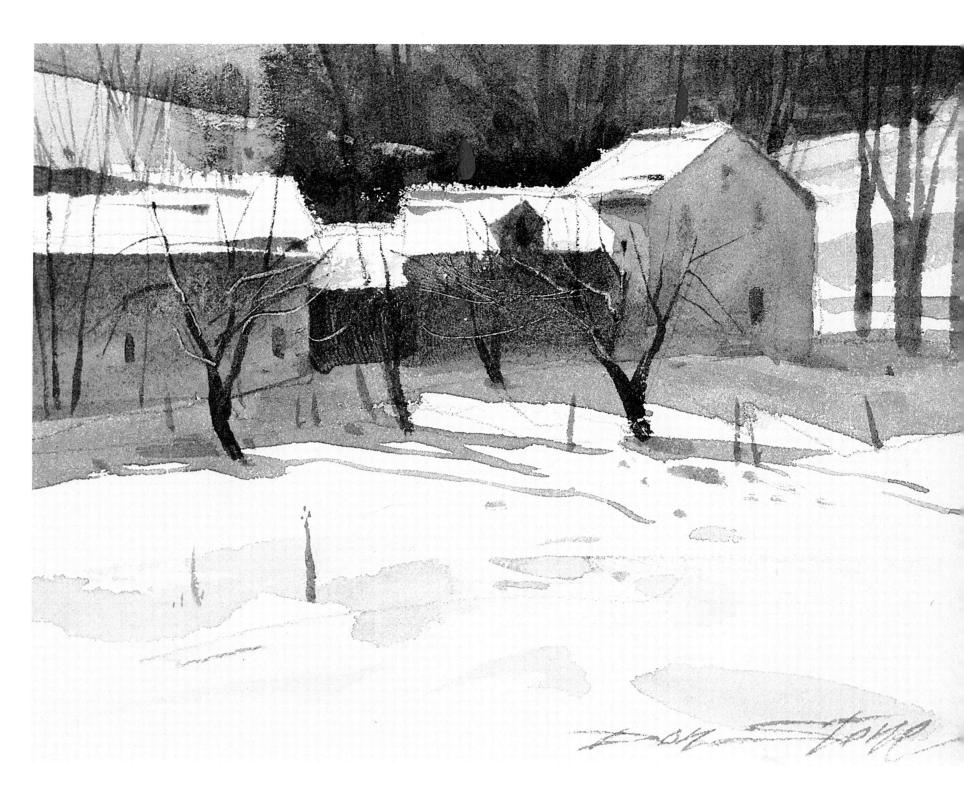

107

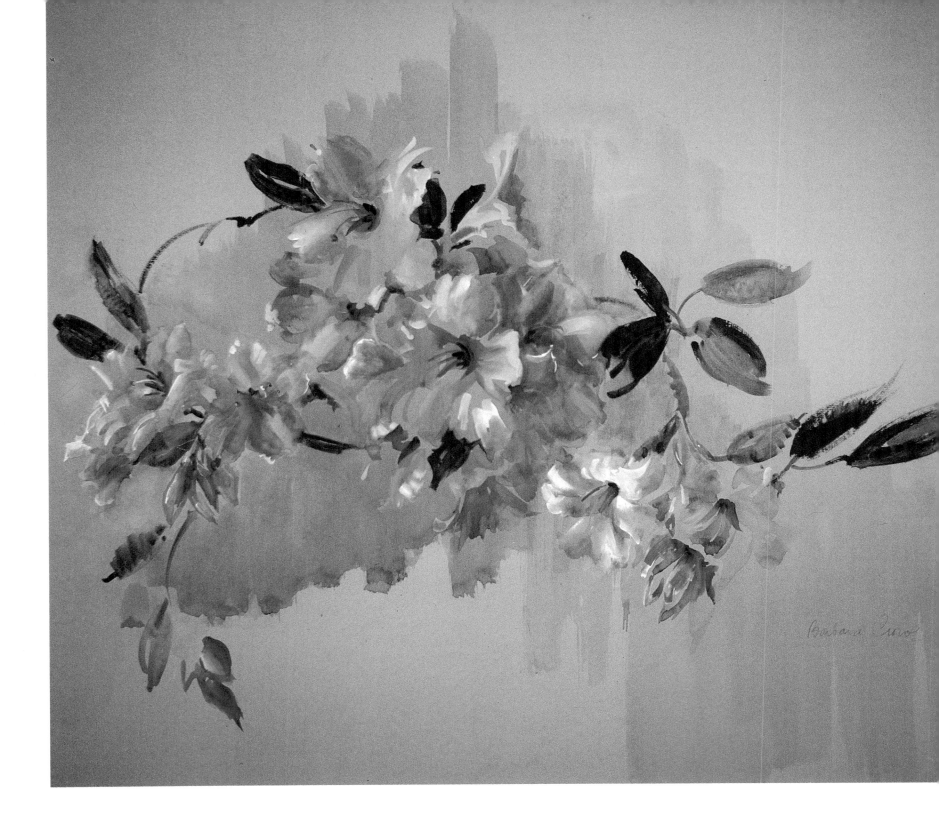

108

Barbara Crowe RI SWA SBA

On visiting the RI Exhibition each year, I have often been attracted to Barbara Crowe's distinctive flower paintings, with their freshness and overall feeling of design. It is always clear that the composition, however apparently loose the arrangements, has been carefully thought out.

There are so many anonymous flower paintings that, although perfectly competent, seem to lack individuality. After all, it must be quite difficult to impress one's personality on a painting when depicting such a fragile subject. Barbara seems to have overcome this difficulty to such an extent that no one could doubt, even from a distance, that this was the work of one individual artist – Barbara Crowe. This is probably one of the factors that persuaded the powers-that-be in the Royal Institute of Painters in Water-colours to invite her to become a member.

Minutes after she and her little dog first met me at the door of her Surrey home, we were chatting away like old friends. She is a jolly, bustling little lady, with twinkling eyes. Her wide and happy reputation as a teacher takes her all over the country running courses, where she loves to watch the development of other people's talents.

An unusual feature about her flower technique is that she usually paints on tinted Canson paper. This is a fairly tough grained surface – very sympathetic to watercolour – and will stand up to quite harsh treatment, especially if it's first mounted on board. It is interesting to note that her near neighbour in Surrey, John Yardley, also uses this paper for his flower paintings (see page 41).

The use of this paper provides a certain unifying factor that gives her work a distinctive quality but has meant that, unlike the traditional purists, she needs to add process white to her other colours which are cadmium lemon, cadmium yellow, raw sienna, vermilion, crimson lake, purple madder, light red, ultramarine, warm sepia and black. It also means that, unlike watercolour painting on white paper, she employs the principle of working from dark to light, as one does in oils, carrying this out throughout the painting.

As she builds up her flowers according to their tonal values, she eventually comes to a point where some parts appear lighter than her tinted paper, and this is where she adds process white to the colours before painting them in. She captures the feeling of depth by varying the thickness of the paint, strong and rich in the foreground, getting more diluted as the flowers recede. She uses her largest brushes whenever possible, and never uses two strokes when one will do.

She feels that the picture should become one harmonious whole, preferring to complete every painting in one session. By attacking the whole thing as quickly as possible she hopes, she says, that the end result will contain more than a spark or two of her original vision.

She has been painting since childhood, spending some time at Croydon Art School before going to the School of Lithography in Fleet Street. After a gap in which she married and brought up four children, she returned to painting and now, as a widow, works full-time, painting, exhibiting and running painting courses.

She waxes almost lyrical about her chosen subject. About her beloved flowers she said, 'I regard them, I'm sure, as a glimpse of Heaven itself, and I feel it's almost an imposition to attempt to portray them at all, in all their loveliness and purity!'

◁ PINK PEARL
There is a very pleasant rhythm and balance about this picture and although the subject is delicate, there's a strength and purpose about it. One of her devices is to throw some of the lighter flowers up by washing in loose strokes of darker colour behind.

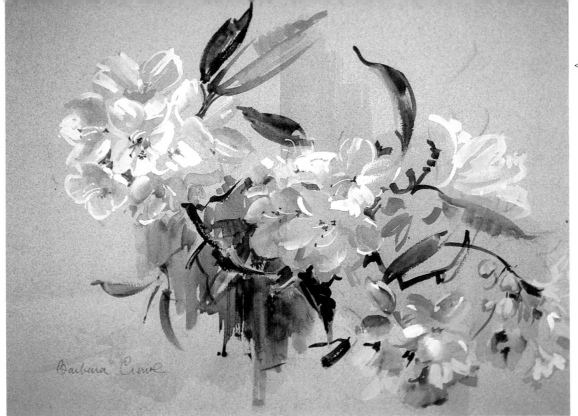

◁ RHODODENDRONS
You can see here the use Barbara makes of the addition of process white to her other colours when painting light flowers. Notice, too, how she counterchanges some of the petals against the dark wash beneath. There's a gentle luminosity about the picture that is very refreshing.

FANTASIA ▷
This is a typical Barbara Crowe mixed arrangement. Although apparently casual, it is obvious that a lot of thought has gone into it to provide a good, balanced flow. The bright yellow rose placed next to the dark foliage makes it the main object of attention.

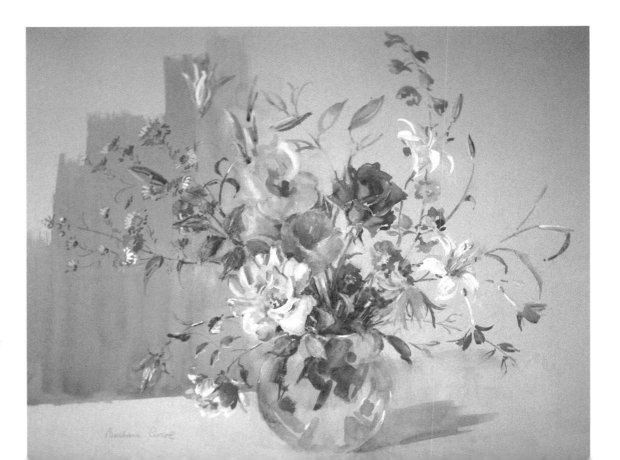

110

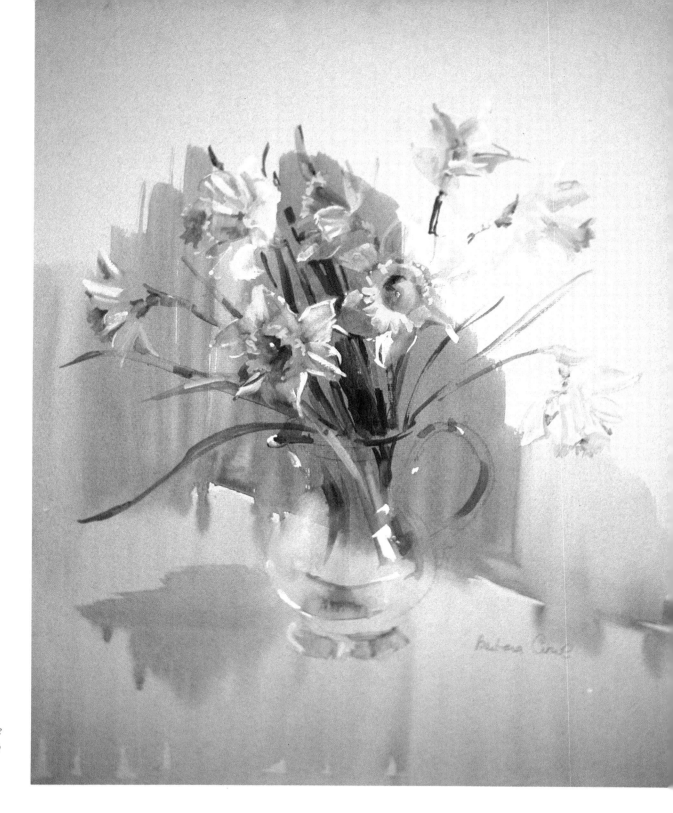

DAFFODILS ▷

This is a particularly lively rendering of daffodils. The loose, vignetted background wash helps to give the painting vigour. I like, particularly, the way she's hinted at the glass jug – just catching the odd highlight – yet no one can be in any doubt as to what it is. Notice how she used some of the dark stems in the centre to throw up the light flowers.

Philip Jamison AWS

Philip Jamison's book *Capturing Nature in Watercolour* has long been a personal favourite and I find myself returning to it time after time for inspiration. It's a gentle, thoughtful book and his paintings have a delicacy of touch that seems to extend to his writing. His whole approach seems to be quieter and less staccato than many of his contemporaries in the US.

He loved to draw as a child and his attitude to art then was that it was 'just plain fun'. However, no one at the time suggested that he go to art school. After serving two and a half years in the Navy and much soul-searching, he finally enrolled at the Philadelphia Museum School of Industrial Art where he studied interior design. As time went on, he found himself drawn increasingly to painting and after two years he changed his course to illustration.

Following graduation, he explored various means of self-expression before finding

his true medium in watercolour, where his influences were many and varied and included Winslow Homer, Edward Hopper, Turner and Andrew Wyeth.

Because all his ideas are derived from nature and he paints in a realistic way he calls himself a Realist. This doesn't mean, though, that he simply copies everything he sees – in fact in many cases he will change almost everything if it enhances a composition or idea. He regards most of his paintings as abstractions with the most important factor being the overall pattern or design.

At one time he painted all his watercolours outdoors, regardless of weather conditions, but now he prefers to work in the studio where he takes more and more time to complete his painting. Formerly he would complete a picture on location in two hours but he may now work on a picture over a period of months or even years, constantly trying to strengthen the composition or to simplify the elements, and yet always attempting to keep them looking fresh and spontaneous.

He has two studios – a winter one in West Chester, Pennsylvania, where he spends most of his time, the other, a summer home on the island of Vinalham in Maine. Virtually all his work is done in and around these locations and has been for years.

His work is shown primarily through one-man shows, which have been held regularly every two years for the last thirty years in New York, Philadelphia and Washington, DC. In recent years he has felt more comfortable working on a small scale and he says 'perhaps I now prefer smaller, more intimate

works of art'.

Philip often works on a whole series of paintings of one subject perhaps using his studio as the main subject, along with flowers (his favourites are daisies which he loves, he says, for their simplicity and purity).

He uses a basic earth-coloured palette of about a dozen colours, but for his flowers he supplements these with cadmium yellow, cadmium orange, cadmium red and mauve. His brushes range from No 2 red sable to a 2½in house-painting brush. Although his favourites are sable, he has high hopes of some of the new synthetic 'sables' as his brushes are given a great deal of harsh treatment in obtaining various textures. He says, as a Scotsman, he finds it very distressing to punish an expensive brush!

He also uses a wide variety of watercolour papers, experimenting with all makes, but still hasn't found one to satisfy all his needs, so he chooses each according to the subject of

MY STUDIO IN JULY ▷
The usual furnishings of Philip's Maine studio are shown in this painting. During the month of July the studio is full of the ever-present pitchers of daisies. The American flag was placed there by one of his children after the 4 July Parade. Obviously, a lot of care and thought has gone into this apparently haphazard arrangement of objects. Notice, too, how some objects – like the foreground chair – are emphasised, whilst the table on the right is almost lost.

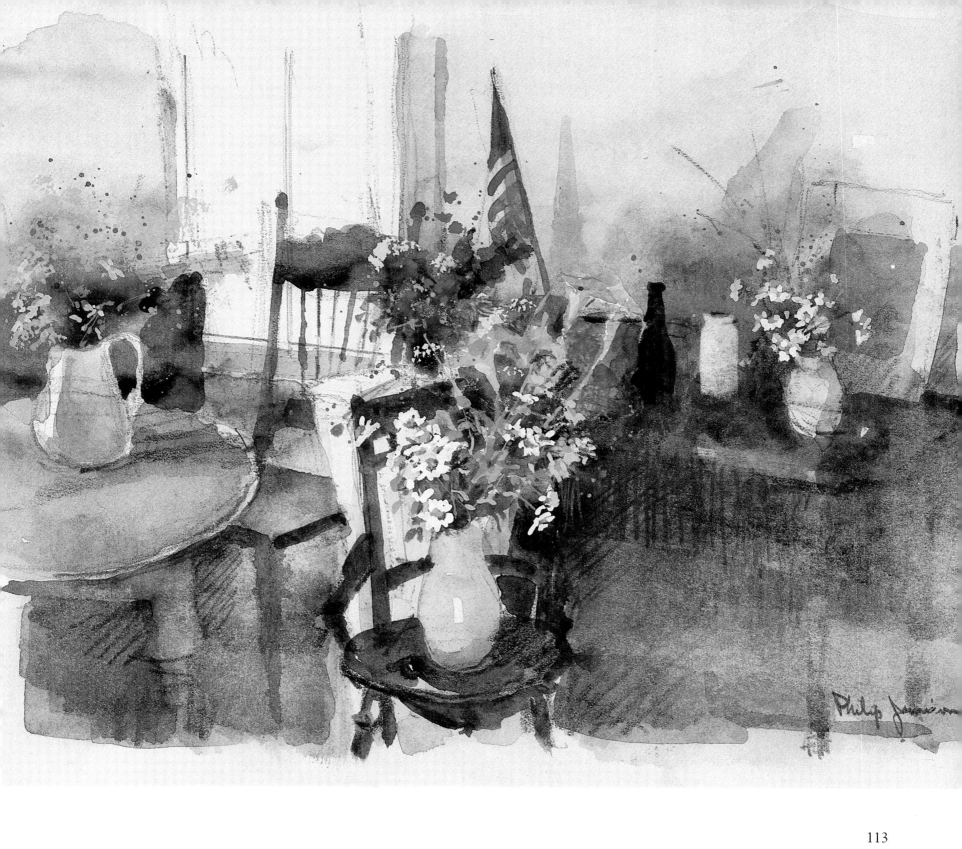

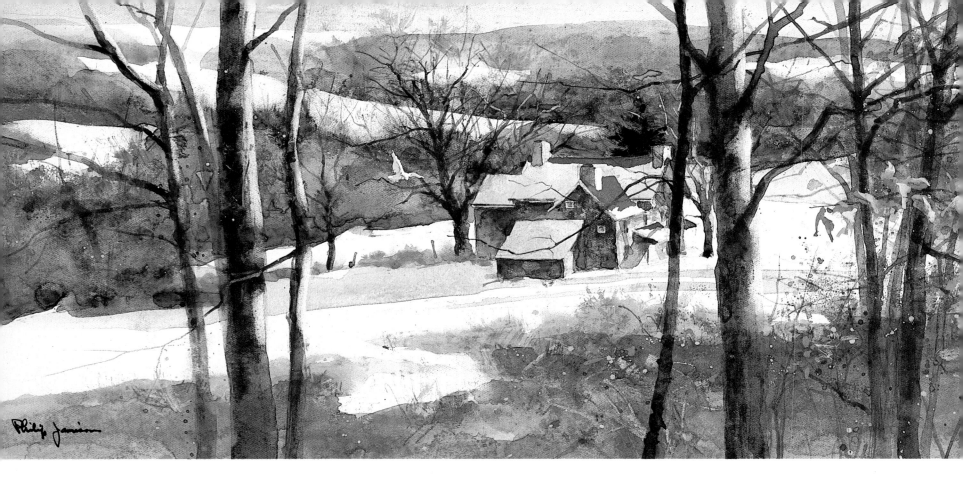

the moment. His only other tools are sponges, both natural and synthetic, for wetting his painting surface and also for obtaining various textures. Finally, he uses a penknife to scrape in suggestions of grasses and small trees.

Over the years he has acquired a large collection of other artists' work – chiefly American from the years 1925 to 1945. None of it resembles his own work but he finds it very exciting as well as inspirational.

To illustrate the sincerity and thoughtfulness of this man: he took the time and trouble to send me a small privately-printed booklet of his thoughts, and those of others he admires, to explain his personal philosophy on his art and life. Here are a few sample quotes from it:

'There is too much emphasis on style. Some students learn to cover up personal inadequacies with it.'

'An artist is someone who is constantly searching for something he never achieves.'

'The paper or canvas, to me, represents a battleground. When I'm through fighting it frequently is left very scarred from the clash. Sometimes I win; more often I lose.'

'Few paintings are as good as the artist imagines them. Fortunately, some are better.'

'Nothing is permanent. However, my work is a hell of a lot more permanent than I am.'

△ ABERNETHY'S HOUSE
The strong vertical trees in the foreground act as a frame for the distant building, giving a feeling of great depth to the painting. The single splash of red on the roof makes it the focal point of the whole picture. The design is built up of alternating warm and cool stripes. Notice, also, the way the white bird is counterchanged against the dark wood.

FLOWER SKETCH ▷
Whilst many of Philip's other paintings have been done over a long period of time, this one has the atmosphere of complete spontaneity. There's a freshness and gaiety here which is enhanced by the loose vignetted background. There's a lovely example here of a riot of wet-into-wet colour.

114

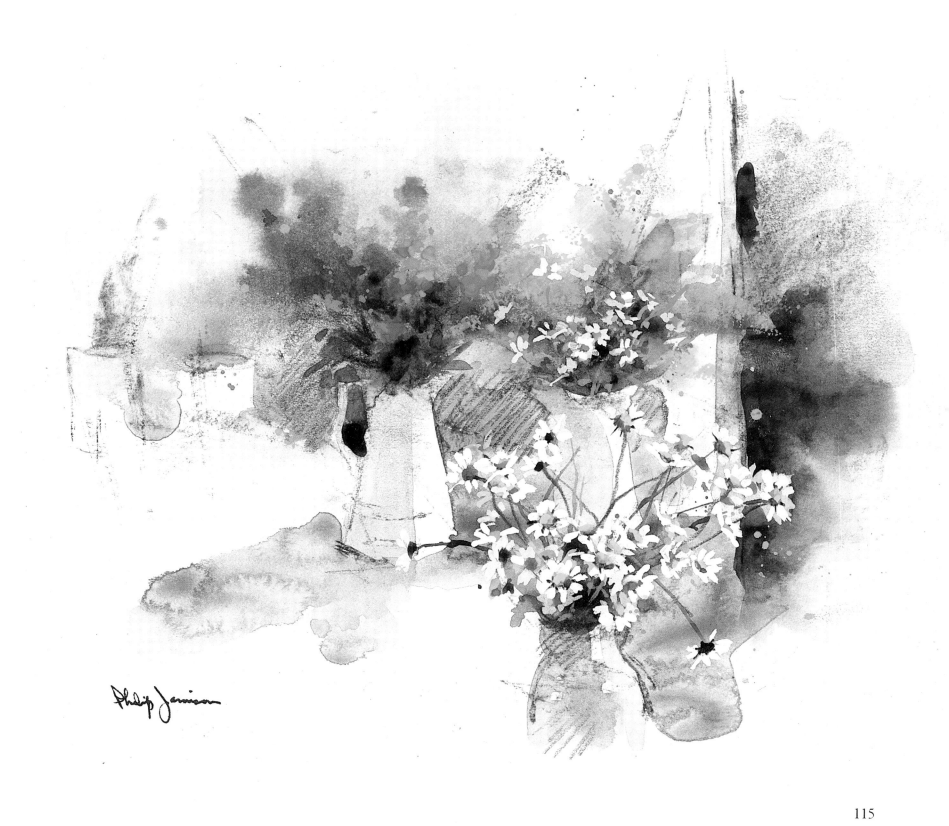

Philip Jamison

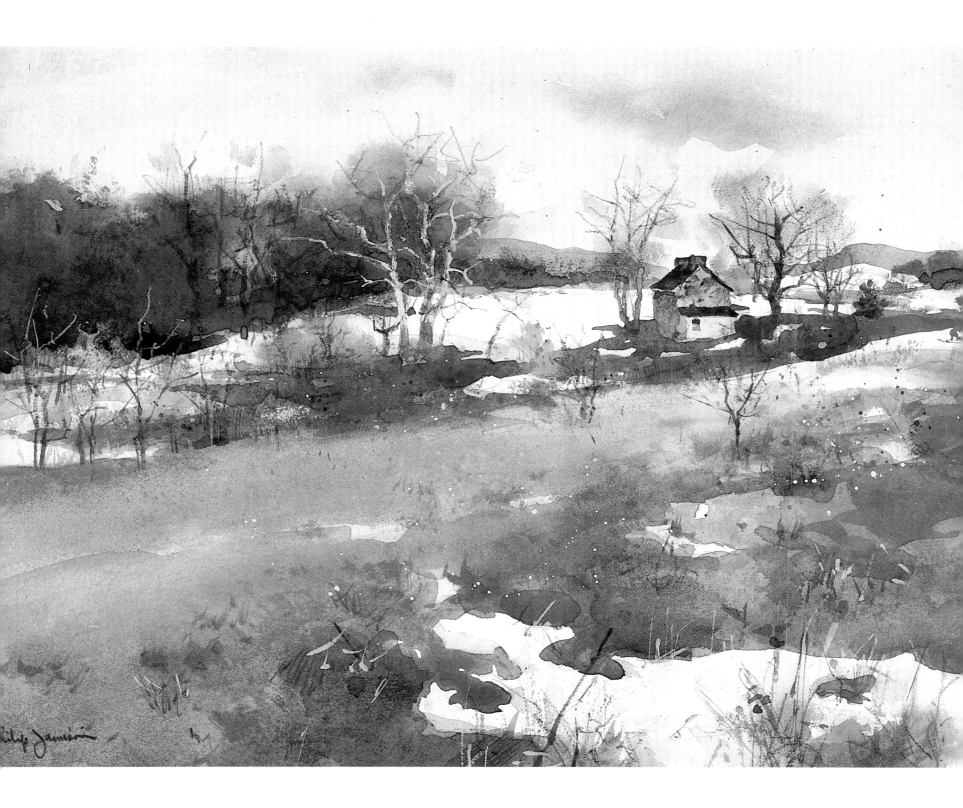

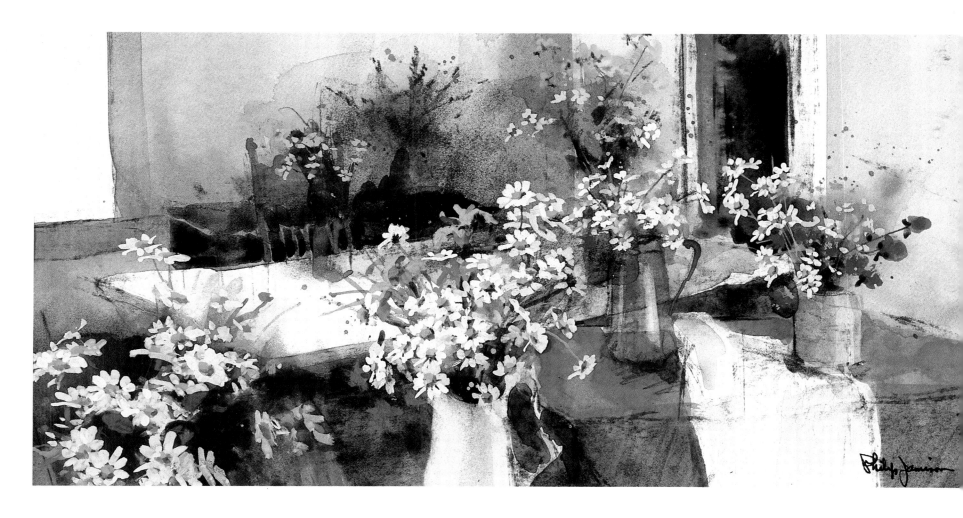

△ SUMMER STUDIO
Whilst on the same basic theme of flowers in the studio, we have a greater richness of colour here. The mauves, reds and golds make this picture really sing. The long white table gives the picture a strong design theme, linking together all the various elements.

◁ WILLISTOWN FARMHOUSE
There's a very strong but subtle pattern to this painting. The patch of snow in the foreground is very important, as it leads the eye into the picture. The delicately counterchanged trees form a link between the foreground field and the horizon. Philip seems to be fascinated by the challenge presented by receding snow.

117

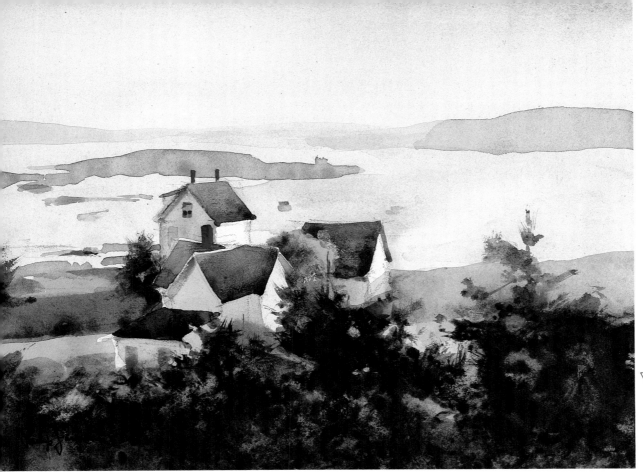

VINALHAVEN, MAINE ▷

This painting typifies one of those times when almost everything went right first time. It was done quickly and needed almost no changes. It contains all sorts of free and wet qualities that belong only to watercolour. The eye is invited through the picture, from the foreground rocks, via the light pools, to the far distant yacht – rather like stepping-stones.

▽ FOGGY DAY

This picture is all about the white light coming in the window, giving contrasting clarity and sharpness to the various objects. Again, the design of the picture is beautifully balanced and there is good use of strong counterchange here.

△ MOUNTAIN VIEW

The journey into the distance is controlled by the relative tonal values of the various parts of the scene, from the rich strong dark foreground trees, via the houses and the island, to the faint hills on the horizon. Notice, too, how all the texture is confined to the foreground and rapidly flattens out completely.

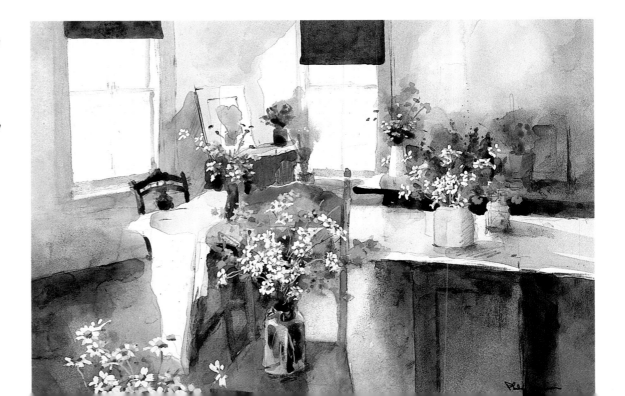

Tony Van Hasselt AWS and Judi Wagner

While wandering around the American island of Monhegan one Sunday morning, I went into a gallery, saw Judi Wagner's work – and loved it! I bought one of her large paintings and took it back to England with me. Soon afterwards I had a nice letter from her saying how pleased she was that I'd bought the picture and that she had my books and videos. This started a postal friendship and the next year I returned and sought out the house where Judi and Tony live and work happily together.

Within moments of meeting them it was apparent that they made an ideal team, complementing each other with their painting ideas and skills. For years they had been like ships passing in the night, meeting briefly on various courses. Both had a connection with the painter, John Pike, having studied with him – Judi had actually worked as his assistant for some years, and John Pike took part in painting holidays organised by Tony. In fact, Judi and Tony finally met properly in 1979.

Combining two strong personalities such as theirs into a working business partnership couldn't have been easy, and it's taken a lot of 'give and take' to get them where they are now.

Before they got together both had successful careers in the art world. Tony grew up in the Netherlands and came to the United States in 1955, where he studied fine art in New York with Frank Reilly, and worked extensively in commercial art. His paintings are owned by corporations and by private collectors around the United States. His company, 'Painting Holidays', was very successful, using more than thirty instructors to lead groups in Europe, in America and in the Pacific Islands. It was a natural progression after he sold his company to set up and teach watercolour (his favourite medium) in his own workshop, which he has done for the last eighteen years.

Judi also worked in commerical art but studied fine art at the Parsons School of

OLD TOBACCO BARN, Tony van Hasselt ▷
This painting is all about textures. The foreground is kept intentionally loose and free and indefinite, concentrating the attention on the structure of the barn with all its decrepit charm. There's a lot of warm colour in the walls and texture was added to the red roof by scratching the paint while itwas still wet. The dark tree on the left throws up the profile of the barn, whilst the tree on the right adds textural interest.

▽ MAINE MIST, Judi Wagner
Two strong curves here encompass the central theme of the rocks and trees. The strength of the rocks is derived from warm colour and counterchange. The dark vertical trees push the distant woods back into the mist.

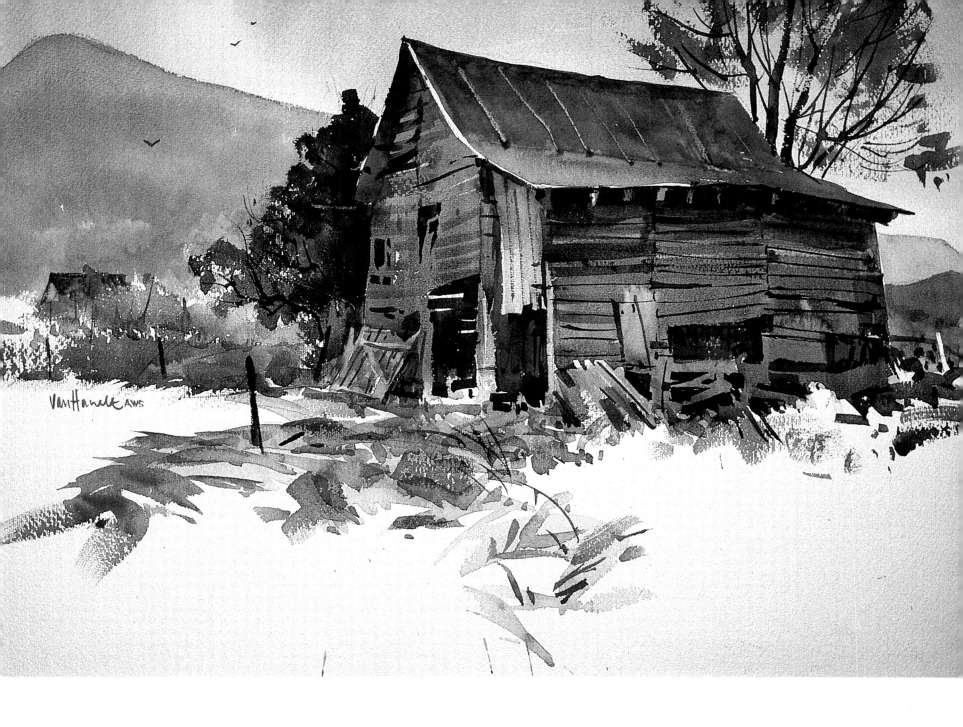

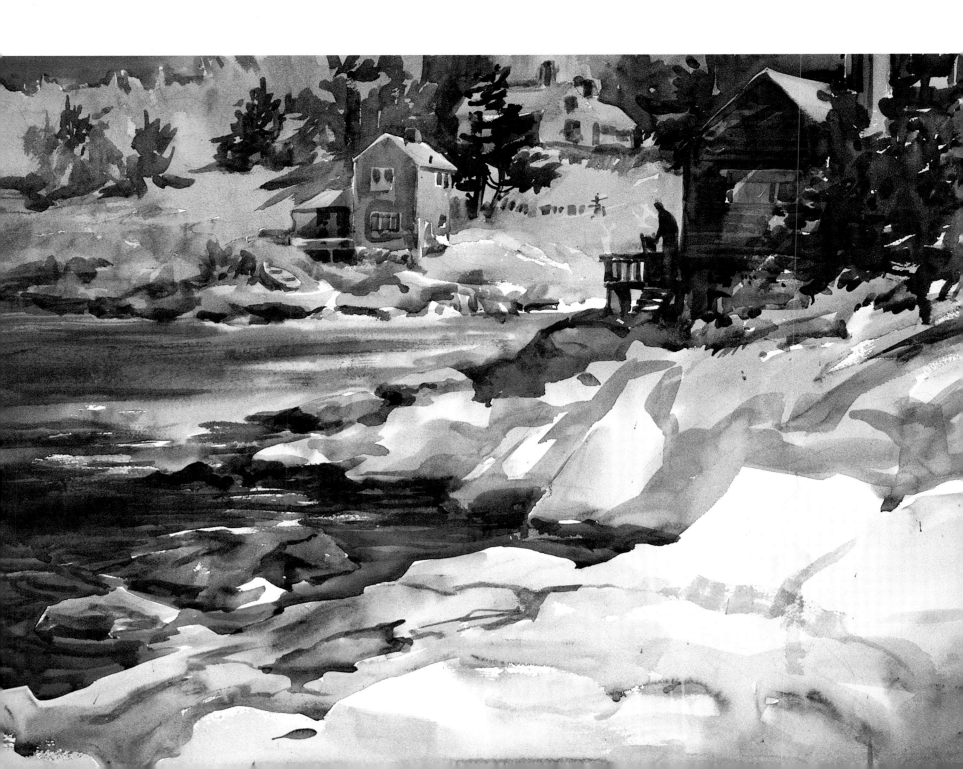

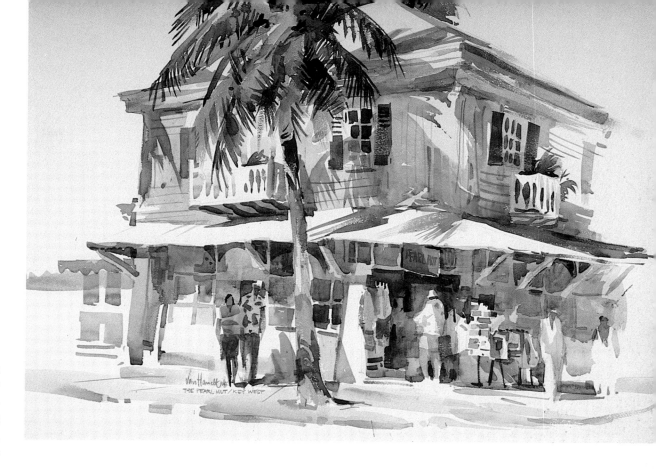

THE PEARL HUT / KEY WEST

△ DEADMAN'S COVE, Judi Wagner
There are three dominant layers in this picture, the foreground rocks, the middle distance with its cabin and figure and thirdly the distant shore with its counterchanged house. The eye is led through the various layers by the zigzag pattern. Notice the way the dark figure is counterchanged against the light grass behind.

Design in New York where she obtained a Master's Degree. After studying with many famous contemporary watercolourists she assisted and taught painting for the Parsons School of Design in Europe for five years, and her total teaching experience covers twenty-three years.

Although it has been said that their painting styles are somewhat similar, they themselves would not agree. However, both stress the elements of good design, colour and concept in their work and you'll notice this in the paintings shown here. They call themselves Impressionists and both paint on location freely and courageously with large brushes, letting their painting express their emotions – getting down their ideas as rapidly and directly as possible.

Individually each has won many awards. Tony has participated in many national shows and became a Full Member of the American Watercolour Society in 1972. He published a book, *Outdoor Watercolour Workshop*, in 1982, but feels that his greatest reward has been to be consistently voted

'Highest Ranked Instructor' by more than 700 members of the Artists' Co-operative Workshop.

Judi has had her work included in various national watercolour shows, such as the American Watercolour Society and many other influential organisations.

Just being with them for a few short hours was an exciting experience and as they waved goodbye to me at the quayside I felt a twinge of envy – here were two people who had not only found each other, but had discovered a way to interlock their talents to provide a unique teaching experience for their students. It is a living and working partnership and as the years go by, each will, I'm sure, stimulate the other to further growth and progress in their chosen profession.

△ THE PEARL HUT, Tony van Hasselt
An interesting pattern throughout this picture is provided by coolness against warmth and light against dark – even the figures themselves are counterchanged against their respective backgrounds. The texture and treatment of the palm tree is very satisfying and it also gives some interesting shadows on the building. There are some lovely rich warm colours under the awning.

THE FREEDOM MUSEUM, Judi Wagner ▷
An interesting jumble of paraphernalia provided Judi with a wealth of subject matter. This difficult subject has been handled with great authority and confidence. Although complex, each individual item has been given its full worth without the picture becoming 'bitty'. The plain wall is a necessary restful feature.

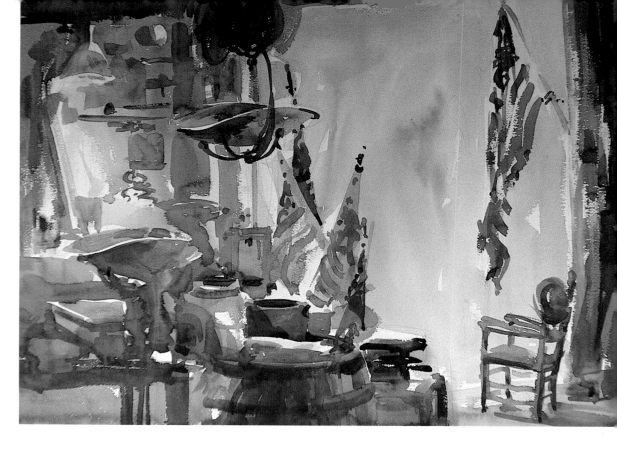

▽ UP ON THE WAYS, Judi Wagner
The boat, here, has been highly dramatised – almost spotlit by subduing the whole of the rest of the painting. There is, however, a wealth of subtle warmth in this dark colour and also the various textures retain one's interest.

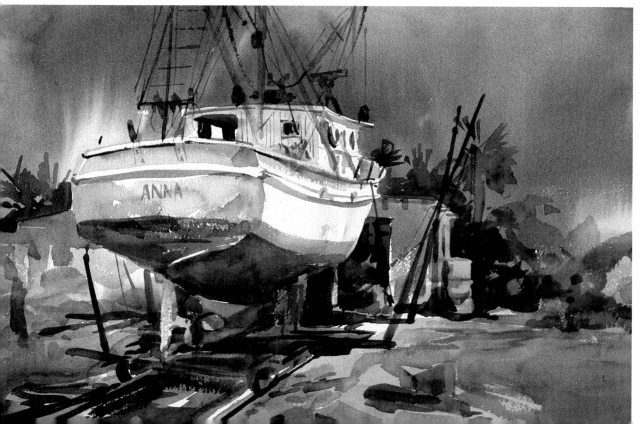

THE CARMEL MISSION, Judi Wagner ▷
This is a picture with a difference. It's unusual to find a flower painting combined with architecture in this way. The two subjects complement each other – the strength and colour of the flowers balance the delicacy of the bell tower. There is a lovely sense of calligraphy about the way the flowers have been indicated on top of the glowing wet-into-wet colour.

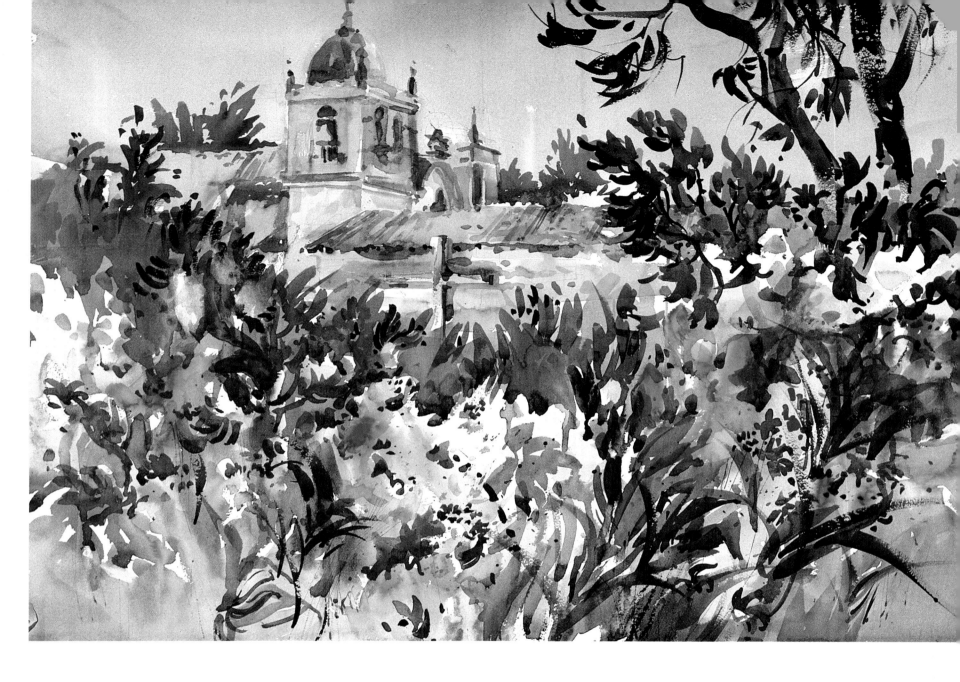

TEXTURES OF MEXICO, Tony van Hasselt ▷
This is a very strong architectural subject; there is much use of counterchange and shadows to throw up the various profiles. The figures too, are very important. They give a purpose, an interest and a sense of scale to the whole composition.

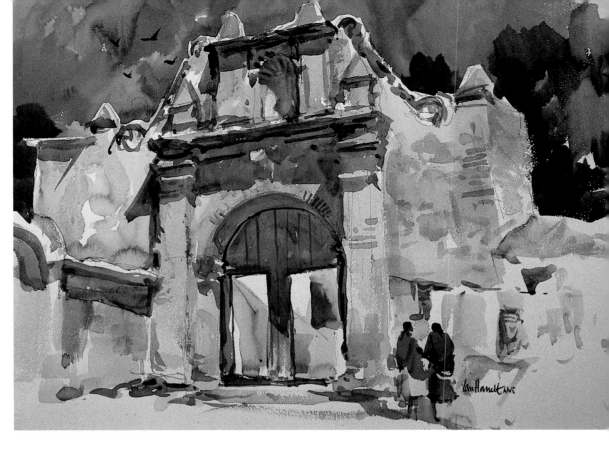

▽ MONHEGAN MOORING, Judi Wagner
Judi has a way with rocks and seems to enjoy their strength and colour. Their rugged surface is indicated by coolness against warmth and dark against light. The delicate, subtle treatment of the boats in the distance also seems to further this sense of hardness and solidity of the foreground.

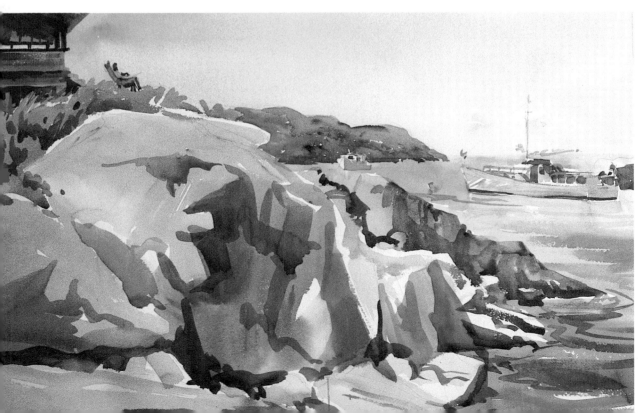

LOBSTER SHACK, Tony van Hasselt ▷
This picture has an overall rich darkness illuminated by several different light sources. The harbour scene through the door is merely hinted at. Because the general colour is so subdued, the painting is dominated by the little patches of pure colour – the life jacket, the floats and the plastic bucket.

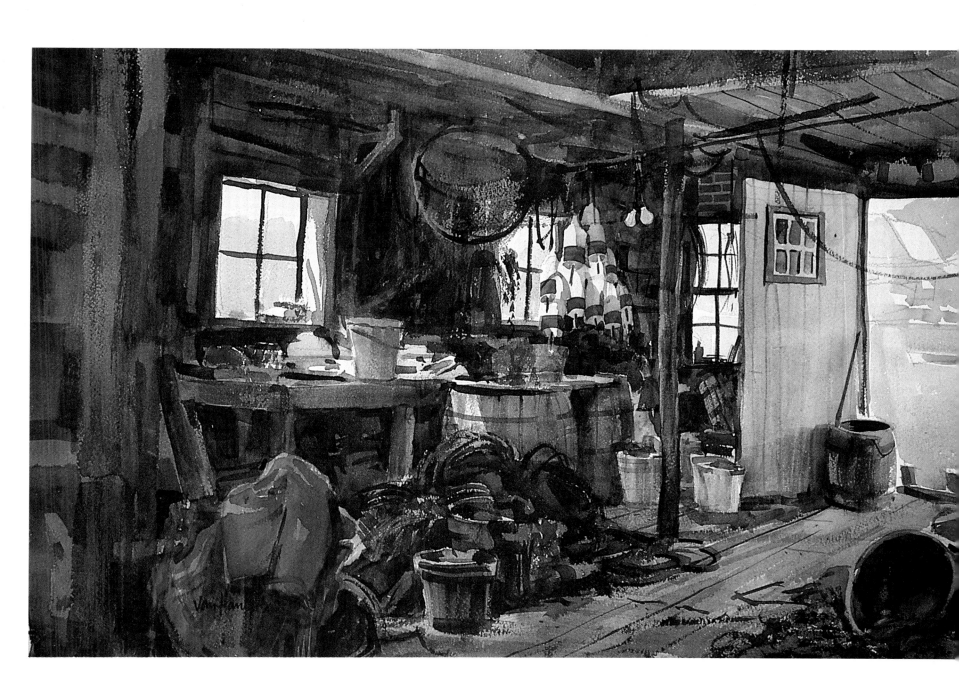

BIBLIOGRAPHY

You may be interested to read more about some of the artists in this book, and to this end here are some books which I believe to be still in print.

COUCH, Tony. *Watercolour – You Can Do It* (North Light, 1987)
CRONEY, Claude. *Croney on Watercolour* (North Light, 1981)
GOODMAN, Jean. *Edward Seago – The Other Side of the Canvas* (Collins, 1978)
HOOPES, Donelson F. *Sargent Watercolours* (Watson Guptill, 1976)
HOOPES, Donelson F. *Winslow Homer Watercolours* (Watson Guptill, 1976)
JAMISON, Philip. *Capturing Nature in Watercolour* (Watson Guptill, 1980)
LEWIS, R and GARDNER, K.S. *Sir William Russell Flint* (David & Charles, 1988)
MERRIOTT, Jack. *Discovering Watercolour* (Pitman, 1973)
RANSON Ron. *Edward Seago* (David & Charles, 1987)
VAN HASSELT, Tony. *Outdoor Watercolour Workshop* (Watson Guptill, 1982)
WEBB, Frank. *Watercolour Energies* (North Light, 1983)
WESSON, Edward. *My Corner of the Field* (Alexander Gallery, 1982)